MAIN
KANSAS CITY KANSAS
PUBLIC LIBRARY
DATE:

779.2092
MARSHALL

JIM MARSHALL

MATCH AND PRINTS

TIMOTHY WHITE

INTRODUCTION BY ANTHONY DeCURTIS

COLLINS DESIGN

An Imprint of HarperCollins Publishers

We dedicate this book to all the people who have come

in front of our lenses and have allowed us to capture their image.

We are honored by the privilege.

JIM MARSHALL

AND

TIMOTHY WHITE

CONTENTS

FROM THE PHOTOGRAPHERS

It all started with my photo of Jim Morrison and Timothy's photo of Robert Mitchum: their heads cocked just so, both cupping their cigarettes with similar authority and disdain. I was so excited by the similarities between the two images that I hung them side by side in my apartment.

It fascinates me that Timothy and I are a generation apart yet have photographed many of the same subjects in a similar context or composition. It fascinates me even more that we have done this with such contrasting styles. We may imagine the same thing, but we execute it differently.

Timothy says that I see my picture at one-sixtieth of a second, while he sees his picture evolve over a couple hours. We may have different approaches, but when we take pictures, we both work on gut instinct. I believe that honesty comes through in our photographs.

The discovery and sharing of each other's work set us off on the path that has brought us here. This book represents our respect for each other's work. I hope you enjoy this creative exploration as much as we have enjoyed the collaboration.

Match Prints is a tribute to friendship, photography, and the sharing of the two.

—Jim Marshall

In the late 1980s, I was a young music photographer making a modest splash on the scene thanks to a cover contract with *Rolling Stone*. I was in L.A. on assignment and staying at the Sunset Marquis when a hotel staff member approached me: Jim Marshall, he said, would like to meet me. Jim Marshall was royalty in my line of work. This man had created some of the most iconic images of 1960s rock 'n' roll. He couldn't possibly want to meet me as much as I wanted to meet him.

To this day, I have never known anyone like Jim. He is loud, loyal, generous, and unique in every way—and he is loved fiercely for it.

Just ask anyone.

Jim and I have always shared a great respect for each other's work. Like our personalities, there are distinct differences, but enough similarities to draw a parallel. Our techniques are dissimilar, even contrasting at times. Jim works with his trusty Leica, making documentary-style pictures that look as though they were shot from the hip of God. He captures real moments with daring intimacy, and the compositions just happen to be perfect. On the contrary, my process is more of a formal portrait session. I take my subject and the immediate

environment into consideration and create a scenario. My reaction to the surrounding circumstances is the picture I take.

Despite our different styles, we share an interest in subject matter and, often, a point of view. As we became more familiar with each other's images over the years, we discovered that we had photographed the same people twenty or more years apart. We also found that some of our work illustrated nearly identical compositions.

Delighted by our observations, Jim and I have had a lot of fun seeking the common thread between our images. *Match Prints* represents the exploration of our juxtaposed work, as well as our love and passion for photography. Making the book with Jim was a special experience for these reasons, but also because he embodies a deep generosity that one rarely encounters. He is a faithful sharer of his work and a sincere supporter of anyone he takes under his wing—he's enthusiastic about photography, be it his or anyone's. I admire him for this quality.

Whenever Jim tells his version of the story of our meeting by the hotel pool, he never fails to mention my excessive use of suntan lotion. For revenge, I bring up his banishment from the Sunset Marquis based on his violent reaction to being served onions. Ask him for the story.

Our differences aside, we are fellow photographers and forever friends.

— Timothy White

PHOTOGRAPHY, FAME, AND FAMILY:
JIM MARSHALL AND TIMOTHY WHITE

ANTHONY DeCURTIS

"I love this man," says photographer Timothy White about Jim Marshall, a fellow photographer who is one of White's most important inspirations. More significant than that, he is one of White's dearest friends.

"I love this man because he's one of the most honest men I've ever met in my life," White continues. "He's honest with himself and he's honest with people. He also has a really big heart. And I know that if I was ever in trouble—*serious* trouble—he would be there for me."

Marshall seconds that emotion. "I love this guy, and I love his wife," Marshall says. "We're twenty years apart, and some of our pictures have been taken thirty-five years apart. Our pictures work together. I don't know how else to put it."

Heartwarming enough for you? Well, that's part of what *Match Prints* is about. Marshall and White have photographed many of the same people and have had opportunities to render their impressions of some of the most important artists of the twentieth and twenty-first centuries. While different in vital ways, their work is complementary. Juxtaposing their images creates energy fields that enrich viewers' comprehension of both their styles and their subjects.

Match Prints is a surprising blend, a shotgun marriage of two unique visions, personalities, and techniques in which the unlikely whole triumphs over the sum of its extraordinary—and extraordinarily distinct—parts. The book is about connections and interrelationships. And in some deep way, it's about love. But it's also about the serrated edges where connections are made, where those relationships are forged and frayed, and where love makes you bleed. Setting the pictures aside, there are and never will be any shortage of serrated edges anytime Jim Marshall is in the room.

So heartwarming is hardly the whole story. You should have been there a few minutes before the lovefest described above, as the two men discussed a potential pairing of photographs that was destined not to make it into *Match Prints*.

The exchange goes down like this. Marshall makes a suggestion, and White is exasperated. "We're going to fight over this for sure," he says bluntly. But, true to his character, White collects himself and explains his reasoning.

"Good point, good point," Marshall concedes, before rousing his legendary temper again. "So why didn't you tell me that two months ago?"

"I did," White responds, his own voice rising. "You just never listen."

"Fuck you!" Marshall fires out. It's his inevitable response when logic just won't do any longer.

"And you," White replies idly. He's so accustomed to Marshall's outbursts that now he barely hears them. He knows Marshall means it only for the instant in which he says it. After that, Marshall quickly settles down, the conversation resumes its friendly tone, and the two men return to the subject of love, the subject at the very heart of *Match Prints*.

This project is the culmination of conversations, challenges, dares, comparisons, and expressions of profound regard that have occurred between Marshall and White since the two men first met in 1988. As they sat and talked about *Match Prints* in White's studio on the west side midtown Manhattan two decades later, the differences between them could not have been more evident. White's workspace, where his staff of six helps keep his high-flying career soaring, is an impressive testament to the degree of success a superb celebrity photographer—White fits the term in both its senses—has been able to achieve since the 1980s.

His studio is, in fact, its own five-story building, an elegant former carriage house that he gutted and completely rebuilt. When

you enter on the ground floor, the first things you see are some of the collectible cars (White has a couple of dozen) and motorcycles (who's counting?) that are not only White's passion but also the source and subject of some of his finest, most boundary-shattering work. Surrounding the table at which the two men sit—and where photographer and filmmaker Danny Clinch shoots their conversation for a documentary he is making about Marshall—are long rows of black cabinets filled with images White has shot over the years.

The environment, like White's work itself, is at once meticulous and sensual. It's rigorously ordered, but with elements of disarray—like the prints for the *Hollywood Pinups* book he recently completed. White's manner too is low-key, charming, and direct. He is polite and soft-spoken, the sort of person who listens as a means of finding common ground. "If conflict can be avoided," his actions say, "what's the point of inciting it? Let's make things easy." He's focused, pragmatic, and efficient, all without showing any strain.

Marshall, meanwhile, sits with the coiled tension of a switchblade. While White's casual clothing is the statement of a workaholic at ease, Marshall is genuinely rumpled. He looks as if, as he no doubt would put it, he doesn't give a fuck, and you better not either. White sips a beer. Marshall finishes off the bottle of whiskey White bought to entertain him on his last visit. Now seventy-three, Marshall works out of the rambling San Francisco apartment he's lived

in for decades. He may have been dubbed "*the rock photographer*" by none other than Annie Leibovitz, but if you want to get in touch with Marshall, call San Francisco information. And if you dial the number and he's there, he'll answer the phone. "Yeah, I go to the potty by myself too," he informs starstruck fans—and would-be clients—when they express surprise that he takes his own calls.

Despite his grueling schedule, White takes care of himself. He's tanned and fit. After years of cocaine abuse, any number of run-ins with the law, and as many bridges burned as built, Marshall now does the best he can. Beneath the gruffness, he's having too much fun to want to die. If White represents the sparkle and gleam, the bright originality, of contemporary photography,

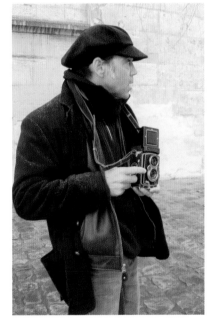

Left: Timothy White, Paris, 2006. Right: Jim Marshall, Monterey, CA, 1967.

Marshall represents the grain of history and the past. Marshall's photographs of such musical titans as Jimi Hendrix, Janis Joplin, Miles Davis, and John Coltrane are inextricable from our understanding of the 1960s. His images have been fully internalized. When we think about that time, his photographs are what we think of.

The 1980s and 1990s present shinier surfaces, but Timothy White finds the depth and wit within them and beneath them. When Marshall began shooting in the late 1950s, photography was a central means of understanding the world. A magazine or album cover could have something like the impact of a church painting in the Renaissance: it could not only capture a moment but preserve it in consciousness and essentially freeze it forever.

Since then, other media such as television, film, and the Internet have flooded the world with images and with new ways of seeing. They have taken much of their inspiration from photography, but they compete with it as well, and often threaten to overwhelm it. Photography's response has largely been twofold. In Marshall's case, he's pretty much indifferent to those forms, although occasionally his pictures can take on the cinematic grandeur of a frame from a French New Wave or Italian neorealist film. For the most part, he intently concentrates on what he does best: creating an

"I ASK [SUBJECTS] TO REALLY GIVE OF THEMSELVES. IN JIM'S CASE, THEY DON'T KNOW THAT THEY GAVE OF THEMSELVES UNTIL HE GIVES THEM THE FILM BACK."—Timothy White

emotionally stunning intimacy that other, more recent media find impossible to replicate.

White, on the other hand, attempts to draw on the energy, excitement, and storytelling possibilities that are so much a part of those

media and channel them into the photographic worlds he creates. His work thrives on its inherent theatricality: because so many of his subjects are performers, this approach suits them extremely well.

Marshall proceeds as a documentarian. His work rests on a traditional notion of authenticity, the assumption that his subjects are imbued with a discernible essence that reveals itself not only in their creative endeavors but also in their everyday actions. He believes that he can capture that authenticity if he is given sufficient access and is allowed to assert his formidable powers of observation. While he is, of course, creating his own works of art in his photography, his style suggests that his subjects are being seen unmediated, alone with themselves, free from interpretation. His goal is a kind of invisibility.

Even though Marshall is present and shooting pictures, his portraits say that this is who these people are when no one is looking. His shots convey an internal feel, a seductive sense of privacy shared, as if he is somehow communicating how these people see themselves, how they look in their own mind's eye, how they believe themselves to be when they are not in public. His pictures are the very soul of unpretentiousness, but there is a profound psychological complexity lurking within their seeming simplicity.

That the vast majority of his photographs are in black-and-white somehow aids in that sense of intimacy. The reality we see every

day may be in color, but in Marshall's hands black-and-white conveys reality penetrated to its core, drained of everything that is unessential to it. It is the black-and-white of film noir—hard, no-nonsense, and insistently true.

White's photographs, meanwhile, assume that all people, whether they are onstage or not, are in some sense performers—conscious of their look, willing to change their look, aware of the image they desire to project. "What subjects allowed Jim to do and what I ask them to do are really two different things," White says. "I ask them to really give of themselves. In Jim's case, they don't know that they gave of themselves until he gives them the film back. There's a difference there. He's capturing something, and they seem to like it, because it's them seeing themselves doing what they do. What I do is not about that. It's outside what they do, so they're looking at themselves a little bit differently."

When his subjects do in fact make their living as performers, White invites them to collaborate in the ever-ongoing process of image making. His work implies that authenticity is not something that is static and capable of being discovered and captured in some final way. He views it and renders it as something that is constantly shifting and in motion. It is, moreover, something that is created, and it creates itself in movement, not stasis.

In his photography, White lends momentum and verve to that motion. With his subjects' conscious cooperation, he helps

invent not just how they will be seen but who they are in the public's imagination. Meanwhile, they share with White a sense of aesthetic detachment from the work they have done together. Whatever their true selves may be—even if that were discoverable—is beside the point. When the next opportunity for play presents itself, whether for a new album, film, or other artistic project, these figures will once again conspire with White to create a self that may or may not have anything to do with the work they have already done together. All these photographs promise is a glimpse into a vivid, dynamic present.

And just as Marshall's black-and-white approach suits his aesthetic, White's dramatic use of color suits his. "Black-and-white is more forgiving," White says. "It doesn't carry with it the illusion of reality the way color does. Color is like, 'Whoa, there it is'—even though, in my case, it's manipulated to the max. I'm totally in control of the levels and opacities and saturation of color."

If reality is in color, White's photographs are often more colorful than reality itself. That super-real aspect of his shots contributes to their intensity—and their playfulness. It is the color of the movies, the color of dreams, and the color of childhood toys—color that is meant to be not simply accurate but gripping, memorable, and fun.

In these very different but profound ways, both Marshall and White have helped define the visual iconography of their eras. Taken together, the photographs in *Match Prints* cover nearly half a century: fifty years of entertaining viewers and

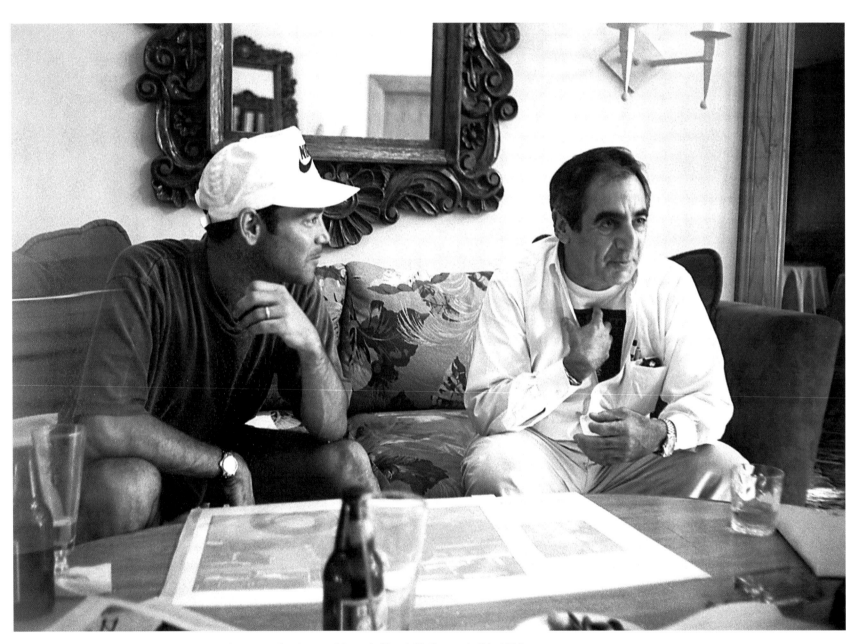

Tim and Jim on the day they met, the Sunset Marquis Hotel, Hollywood, CA, 1988.

teaching them how to look at the increasingly mediated world around them. These match prints are not only echoes of each other in their choice of subjects and themes. They are matches in that they ignite each other in their proximity—generating ideas about the work of these two formidable artists, about the differences and the rarer but no less significant similarities both in their approaches and in the lives and artistic contributions of their subjects. These are images that speak to each other, and to us, in exciting, evolving ways.

They are also matches in the sense of contests—a friendly competition between two friends not so much to outdo as to out-inspire each other, as if to say, "That's great. Let me show you what I've done along those lines." Each of these shots finds these men striving to show their best version of the person or theme at hand. They are signs of mutual respect. And mutual affection.

———————————————

"The day I met Timothy at the Sunset Marquis, he was at the pool, at the cabana," Marshall recalls, laughing. "He looked like an oiled rat. He was really darkly tanned, and he had oil all over his body. You remember?" He glances over at White, who is shaking his head in mock dismay.

"I was waiting for this one, so go ahead," White says in resignation.

"I used to stay there," Marshall continues, "and the manager knew that we were both photographers. He said, 'Do you know Timothy White?' And I said, 'No, but I love his work.' So he told me that Tim was there, and he introduced us."

"So Jim came up to the pool, and I was by the pool by myself, lying in the sun on a day off," White remembers. "He said, 'Hi, I'm Jim Marshall, and I'm a big fan of your work.' I said, 'Get the fuck out of here! You're a legend. I'm a kid from New Jersey. What do you mean, you're a fan of my work?' So we started talking and we hit it off."

That casual introduction at one of the great rock 'n' roll hotels in Los Angeles—could the setting have been scripted any better?—prompted a conversation that continues to this day, and in this book. Like all creative fields, photography is rife with competitiveness and generational conflict. You can easily imagine a third-person introduction of two figures as distinct in their ways as White and Marshall eliciting coolness

and reserve: the older artist suspicious of the young pretender to the throne, the younger man reluctant to yield the heat of the moment to a venerated idol from the past.

Instead, the two men discovered a mutual appreciation. Marshall remains as alive and energized as photographers half his age. He keeps up with the generations of photographers who have followed him, he appreciates great work when he sees it, and he's not above reaching out to let younger colleagues know that he enjoys what they're doing. "I used to see Timmy's stuff in *Rolling Stone* and other magazines," Marshall says. "There's an elegance to his pictures. I don't think mine are elegant. Mine are more immediate. I'm more editorial; Timmy is more thought-out. I work by myself; Timmy works with a crew. I'm

more a photojournalist type, and he's more of a studio type. I'm not good in a studio. That's not my forte. That's not what I do. My forte is just hanging and taking candids."

"The majority of my shots aren't studio necessarily," White responds. "But they are contrived. They're set up; they're lit. I am very reactionary, but in a very different way than Jim is. I'm reacting to light, to subject, to feelings, and then I act accordingly. Jim is reactionary in that he weaves his way into situations and manages to capture moments. His presence is accepted by his subjects, and they allow him into their world in a different way than I'm allowed into their world."

White too is aware and respectful of his predecessors, but his affection for Marshall also relates to his fondness for the past, an element evident in his pictures. As up-to-the-minute as his work is, White holds a profound regard for the lore and imagery of classic Hollywood and the early, insurgent days of the music industry. He's not a nostalgist, but amid all the glamour and excess of those worlds, he senses an innocence that he still feels within himself but

"I'M NOT GOOD IN A STUDIO… THAT'S NOT WHAT I DO. MY FORTE IS JUST HANGING AND TAKING CANDIDS."—Jim Marshall

which he fears may be gone from the modern world he moves in. It's as if he still can't believe he's been allowed to enter the magical worlds of music and film, and the work of someone like

Marshall, who was there in the beginning, recalls a time when magic was all there was.

"When Jim was in his heyday of shooting, rock 'n' roll hadn't made money yet," White explains. "The artists hadn't become famous yet. Jim would get paid something like a hundred fifty dollars to do an album cover shoot. But what was allowed in exchange for that was access. There was no paranoia. It was like, 'We're all just friends, and we're all having fun. You've got a camera? Great! Take some pictures of me. We're all the same age. We're all at the same level. We're all just starting out.'

"When I came into it, rock stars were stars already," he continues. "They were famous. They had publicists. They had managers and agents. They were celebrities. They made serious money.

They were photographed by photographers who were making more than the artists themselves made back in Jim's day. So when I came into this, there was a big difference between who I was and who my subjects were. There wasn't exactly an intimidation factor, but I had to prove something to cut down those barriers."

To illustrate, Marshall's portrait of Rolling Stones guitarist Keith Richards was shot during the Stones' tumultuous tour of the United States in 1972, a tour Marshall says was "fueled by cocaine," a pleasure Marshall indulged in as eagerly as anyone else in the band's entourage. He has the pictures, the stories, and the perforated septum to show for it. "I was shooting for *Life* magazine," Marshall recalls. "After I was on the road with the band for a

week, Keith looked at me and said, 'Jim, what are you doing?' I said, 'I'm shooting for *Life* magazine.' And he said, 'Oh, I guess that's all right.' He had no idea what I was doing there, but I had total access."

Marshall's photos, then, reflect the circumstances in which they were created. "There's a rawness to Jim's work," White points out. "But there's something that's most important about Jim's work that I'm very conscious of when I look at it, and that's the moment—that there is a moment captured. Something happened the moment before and the moment after, but Jim's moment is the one that's fundamental."

"I really feel very strongly about what Cartier-Bresson said—the decisive moment," Marshall says. "I think I do capture that."

"Jim's photography is about a sixtieth of a second," White says. "Mine is about a couple of hours. There's a difference. What I get out of a subject, I work out of that subject. Jim does the work in his pictures. In my pictures I make them do the work. I'm trying to transcend the moment in some way through the manipulation of my materials, whether it's the camera, the film, composition and lighting, post-production digital techniques, whatever. In that sense we shoot very, very differently. Jim is dealing with the moment that he sees in front of him, and I'm dealing with the moment that I'm trying to create. I'm imposing my vision on this environment.

"When I look at Jim's pictures, I'm aware that the moment that he caught is a special moment. Just look at that shot of Hendrix setting

his guitar on fire. It doesn't get any more in the moment than that."

The photo White is alluding to is Marshall's classic shot of Jimi Hendrix lighting his guitar on fire during his cataclysmic performance at

"WHEN I LOOK AT JIM'S PICTURES, I'M AWARE THAT THE MOMENT THAT HE CAUGHT IS A SPECIAL MOMENT. JUST LOOK AT THAT SHOT OF HENDRIX SETTING HIS GUITAR ON FIRE. IT DOESN'T GET ANY MORE IN THE MOMENT THAN THAT."—Timothy White

the Monterey Pop Festival in 1967. That festival launched the Summer of Love, and it launched Hendrix's career. Of course, Marshall was there to shoot it. White's match for the Hendrix shot is an ecstatic performance shot of Eddie Van Halen, his guitar neck in flames as if the very fleetness of his fingers had caused the conflagration. His head is thrown back in orgasmic glee, and his guitar seems to be erupting from his crotch, evincing the phallic power of the instrument so crucial to rock 'n' roll. It's a visual language Van Halen learned from Hendrix—and, for that matter, that White learned from Marshall's generation of photographers—and both photographer and subject make it their own through sheer conviction.

When Hendrix set his guitar on fire, kneeling on the stage in a kind of improvised voodoo ritual, he may or may not have been aware of the possibly apocryphal story from a decade earlier of Jerry Lee Lewis burning his piano to close his

set because he was angry about having to take the stage before Chuck Berry. "Follow that, nigger," Lewis reportedly said to Berry as he left the stage. Now Hendrix follows it. In Marshall's photo, Hendrix is reclaiming rock's Promethean fire, and reclaiming the rock 'n' roll life force for the African Americans who invented it.

"I met him at the sound check earlier that day," Marshall recalls about his first encounter with Hendrix. "I said, 'My name is Jim Marshall, and I'm going to be taking pictures. Are you cool with that?' And he said, 'Maybe this is supposed to be.' I said, 'What do you mean?' And he said, 'The dude who makes my amplifiers is named Jim Marshall.'"

Marshall amplifiers were a key component of the psychedelic rock of the 1960s, as Jim Marshall the photographer well knew, and he told Hendrix so. "But what you don't know, man, is that my middle name is Marshall," Hendrix replied.

"He was James Marshall Hendrix," Marshall recounts. "So there were three Jim Marshalls on the stage at the same time. That night I was right behind his monitor. I was three feet from him on the stage." And Marshall was prepared. Before he walked out onto the stage Hendrix spied Marshall and told him to make sure he had film in his camera. "He didn't say what he was going to do," Marshall says, but the photographer knew that Hendrix had something wild up his sleeve. The result is one of the most indelible images in the history of rock 'n' roll. "He wrote his name down forever that night," Marshall says. Marshall did too.

But Hendrix's remark suggests that, even in a documentary-style shot of a live performance, a conspiracy exists between the photographer and his subject. Hendrix's forethought and his cuing Marshall to be ready hint of the sort of planning that goes into White's more conceptual shots, a secret sharing of intent that binds the two men's work.

The matching shots of Jim Morrison and Robert Mitchum smoking similarly get at some of the connections between their approaches. Both subjects exude a masculine sexuality, and the cigarettes only enhance their images as risk takers. But, again, the lines between straight documentary photography and pre-planned portraiture blur.

"I took that shot in 1968 in San Jose, California," Marshall recalls of his Morrison shot. "We were on the side of the stage, and Morrison just said, 'Hey, Marshall, you want a fucking picture?' And he just looked right into the camera. And that was the last frame on the roll. He was very aware that I was shooting."

White's striking portrait of Mitchum, meanwhile, involved far less preparation than his work typically does. Marshall regards it as "one of the greatest portraits ever done. There's an intensity about it. The Robert Mitchum that I saw on the screen? That's him."

"I took that picture in a parking lot outside a hotel in Santa Barbara," White says. "Most of the people that I photograph, I'm excited by. That's why I continue to do it after all these years. And this man represented black-and-white movies to me. He represented my

childhood—growing up obsessed by all those movies from the 1930s and 1940s that I loved so much. So to meet him, to have him in front of my camera, was a serious thrill.

"When I showed up for the shoot, I couldn't find him," he continues. "I found him in the bar with three empty martini glasses in front of him. I introduced myself, and he just said, 'Okay, kid, let's go.' I had set up in the parking lot, and he started to get into it. He started playing with me, and I started to walk around him with the camera. He started to posture a little bit, giving me his tough-guy thing. And I just saw this gesture that seemed so real to me, right out of the 1930s, smoking a cigarette that way, sucking it in."

Marshall's 1963 photo of Bob Dylan rolling a tire along then-cobblestoned Sixth Avenue in New York's Greenwich Village is another classic of its era. The notoriously guarded Dylan rarely would allow himself to be so relaxed with a photographer in the future. The shot captures Dylan at a moment that he himself would describe as "freewheelin'." He was on the verge of the fame that would prove such a burden to him—on the verge, but not there yet, not yet the spokesman of his generation, still just a young songwriter trying to make his way. And for that reason he's able to enjoy himself with the freedom of childhood and innocence, before experience sets in.

White's evocative match for Marshall's Dylan shot is his pensive photo of Julia Roberts seated among stacks of tires. Here too is a kind of innocence regained—a beautiful movie

idea of shadow boxing. That there's no one else in the frame for Joel to battle but his shadow is perhaps a comment on the internal struggles within the psychology of the fighter, a subject Joel himself has written and sung about.

Shadows also factor into Marshall's portrait of Jerry Lee Lewis outside Sun Studio in Memphis, where Lewis helped invent rock 'n' roll in the 1950s. It was a rare instance of Marshall artificially lighting a shot to get a specific effect. "I always felt that Jerry Lee has cast a long shadow, so we lit it to cast a shadow up the front door of Sun Records," Marshall explains. Lewis had collected Marshall's photos of his peers—men such as Waylon Jennings, Kris Kristofferson, and Johnny Cash—and, like Miles Davis, he had a question for Marshall: "What's taken you so damn long to get around to me?"

White points out the funny coincidence that while their photos were taken decades apart, both he and Marshall decided to take Lewis out on the street at night. "My picture ended up being his Christmas card that year," White says. "So I got a Christmas card from Jerry Lee Lewis with my own picture on it!"

Turning to their shots of Eric Clapton, White jokes, "This is like the stages of man." Marshall's photo, taken in 1967, for *Teen Set* magazine of all places, while Clapton's band, Cream, was on tour, depicts the guitarist decked out in all his psychedelic glory. White's shot, in contrast, portrays Clapton, by then in recovery from a devastating, decades-long battle with addiction, in much more down-to-earth terms.

"This was a man who was called God," White says, referring to the "Clapton is God" graffiti in London that declared the guitarist's instrumental prowess in the mid-1960s. "Although I hold that reverence for him, I don't think my photograph displays that. He conveys a lot of power and presence, but sitting there with worry beads wrapped around his hand, he's a different man from the guy in Jim's photo. The guitar is not something he's fretting over, no pun intended."

Bruce Springsteen's well-worn guitar, along with the right hand that strums and picks it, plays a central role in a distinctive shot by White that's paired with Marshall's shot of Thelonious Monk's left hand holding a cigarette near his piano's keyboard. "I was shooting Monk for the *Saturday Evening Post* in his apartment on West

Sixtieth Street in 1963," Marshall recalls. "He had a baby grand in his kitchen, and his ring said 'Monk' in diamonds."

As for White's shot, he says, "That's an unlikely picture for me. Being a Jersey boy, Bruce meant a lot to me growing up. He's just a few years older than me, and I saw him on the Jersey Shore when I was fifteen. When I was shooting him, I went to move his guitar at one point, and he went, 'Eh-eh'—meaning 'Don't touch that guitar'—and I realized immediately what that guitar meant. And there was another moment where I saw the back of his guitar, and I could see how gouged out it was from his belt buckle from all his years of playing it onstage.

"That changed my sensibility for that shoot," he goes on. "It made me go, 'Whoa, that guitar,

Tim shooting Shirley MacLaine as she shoots his reflection in a mirror, Hollywood, CA, 1991.

those hands—that's what this is about.' This guy isn't about ego. It's not about his face. What it's about is that guitar and those hands."

An instrument also figures prominently in White's portrait of the Queen of Soul, Aretha Franklin. Franklin is known to the public as a singer, of course—one of the greatest ever, in fact. But she is also a brilliant, rhythmically charged pianist. If you recall the opening of her 1968 hit "Think," you'll get a good sense of how her playing galvanized that entire track, providing the perfect setting for her astonishing vocal. Franklin's producer, the late Jerry Wexler, always claimed that he ignited her career by sitting her at the piano in the studio and involving her in the creation of the music for her songs, as well as the singing.

"That was at the Fillmore West," Marshall says about his shot of Aretha dancing as she sings, the crowd reaching up to her like supplicants approaching royalty. "She was on a ramp extended into the audience from the stage.

The audience was delirious! She really worked them up. She's an amazing performer."

"As I've said, a lot of the people Jim photographed, when he photographed them, weren't legends yet," White points out while looking at his and Marshall's shots of Aretha Franklin. "They were his peers. Most of the people I've photographed were legends when I met them. This is a perfect example of that. When he shot Aretha, she was young and energetic. She was in the moment.

"My shot of her is a fun image," he continues. "I mean, Aretha's out there. She's in her own world. She does what she wants, and you allow her to do what she wants. The piano is something that she wants in her pictures. The fact that it's there was important to her."

"That's in her backyard?" Marshall asks.

"Actually, we brought it in," White explains, laughing. "It's a rented house—it's somebody else's backyard! And again, we come back to the contrivance of my photographs. The real question nowadays would be, did you put the piano in after the picture was taken? But we didn't in this particular case.

"The funny thing is that Aretha had a tooth missing in front that day," White goes on. "I was like, 'Aretha, what am I going to do?' And she said, 'Don't worry about it. You go back to your camera.' She says that a lot! But she was chewing gum, and she shaped the gum between her teeth. That's just who she is. And I asked her to sing for me. I was looking to get a moment of her lost in song.

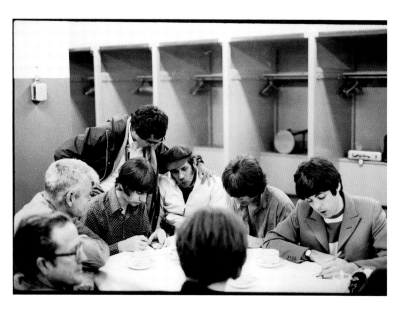

Jim and Barry Feinstein backstage with the Beatles, Candlestick Park, San Francisco, CA, 1966. This picture was taken with Jim's camera by an unknown photographer.

She started singing, and as soon as she had a real moment, that was it."

One of Marshall's innumerable coups in the 1960s was shooting the Beatles' final concert appearance, which took place in 1966 at San Francisco's Candlestick Park. Marshall's shot of John Lennon backstage at that show depicts him as a man in thought and a man in transition, both vulnerable and hardened, already gone past the performance that is yet to come. In the shaggy bangs, you can see the last remnant of the cheerful moptops, the Fab Four who conquered America with a bracing shot of optimism in the immediate wake of John F. Kennedy's assassination. But his squinting, defiant eyes—Lennon was shortsighted and vain, often refusing to wear his glasses—and his unsmiling face presage the rebellious years to come. Looking at the photo, White says, "Jim worked with the Beatles; I grew up with them. There's a difference."

"I was the only photographer allowed backstage," Marshall recalls. "The Beatles were very pensive backstage; they were burned out

by that point. But the minute they hit the stage, magic erupted. They were unbelievable. To this day, you cannot convince me that they knew that would be their last concert. I do not believe that."

White's shot of Julian Lennon, John's son, is similarly contemplative, though Julian, with his arched eyebrows and his right hand protectively in front of his face, lacks his father's aggression. "The influence that John had on my life became an important part of my relationship with Julian," White says. This pairing, then, is a double generational echo, from Marshall and John to White and Julian, from fathers to sons.

White was able to penetrate the world of the Beatles again when he shot Paul McCartney for the cover of *Rolling Stone*. White was chasing McCartney for a particular shot of him on the side of the road—McCartney was touring for the first time in many years, so an "on the road" shot was the order of the day. White ended up being asked if he wanted to fly with Paul and his wife, Linda, from Chicago to Toronto, where they'd be able to accommodate him.

"I was only able to take very little equipment—whatever I could carry on and fit into my pockets, essentially—and no crew," he recalls. "I get on the plane, the doors closed, and it's just me, Paul, and Linda on there. It was really special to have that moment with someone whom I idolized as a kid. Seeing them together, I got such a sense of who they were and how bonded they were. That's what the shot in the book represents to me."

Matched with Paul and Linda is Marshall's portrait of Johnny and June Carter Cash, another of popular music's storybook romances. "I got to know John in the early 1960s, and we were friends to the end," Marshall says about Cash, who died in 2003. "I shot him in 1968–69, when he was at the height of his powers. I had total access. I could do whatever I wanted, because he trusted me.

"In fact, the next book I'm doing after this one is going to be called *Trust*, because for a lot of my pictures, I was given that trust, and I've never let it be violated," he continues. "I've never been sued. I've never had a manager, agent, lawyer, or artist call and complain about what picture I used or where I used it. Not one fucking time. I can live with that."

Marshall's stark portrait of Ray Charles waiting for a limousine backstage at the Longshoremen's Hall in San Francisco in 1960 strikes a marked contrast to White's euphoric photo of him in Culver City in 1991. Charles would be arrested for possession of narcotics in 1961, and Marshall's portrait renders the forbidding figure Charles had come to be at that time. "I did a couple of his album covers," Marshall recalls, "and I don't think I ever exchanged a hundred words with him." He pauses for effect. "And I don't think he ever liked the pictures I took of him," he deadpans, before breaking into laughter.

By the time White began to shoot Charles, the singer had straightened out his life and been recognized as a national treasure. He hadn't lost

his edge, however—or his sense of humor. "I photographed him five or six times," White says, "and he actually said to me at one point, 'I don't care—do what you want. I'm never going to see these things anyway.'"

On the day this photo was taken, one of White's assistants had brought some rare recordings by Charles to the shoot. He began playing them as Charles walked into the room, and the singer immediately responded. "He was remembering the names of all the musicians who had played with him on that record," White says. "He was going, 'Wow, listen to that!' It opened up his face, and it lit up his world.

"The difference between these two pictures is startling—the exuberance of my Ray, and the somberness of Jim's Ray. This was a moment Jim found of Ray alone. Mine was a moment of recognition. It was such a wonderful moment to be part of, and in fact we created it, and it brought so much out of this guy.

"I PHOTOGRAPHED [RAY CHARLES] FIVE OR SIX TIMES," WHITE SAYS, "AND HE ACTUALLY SAID TO ME AT ONE POINT, 'I DON'T CARE—DO WHAT YOU WANT. I'M NEVER GOING TO SEE THESE THINGS ANYWAY.'"

"When I talk about my photography with people," White continues, "I always talk about the experience for me. That's what I'm interested in. I almost don't even care about the final photo in a way—although of course that's what I'm there for, and of course that's important.

But it's about that experience. It's about that interaction with these people who have changed the world—and changed my world, emotionally, intellectually, artistically."

The earliest photograph in the book is Marshall's 1959 shot of comedian Lenny Bruce performing at the hungry i in San Francisco. "That's the first roll of color I ever shot," Marshall recalls. "Forty years later, Fantasy Records called me and said, 'Jim, we found some of your shots. Come and get them.' They had fallen behind a cabinet and stayed there for forty years. But Lenny Bruce was great. Every comic today should begin their set with the words 'Thank you, St. Lenny.'"

White chose his compelling portrait of Chris Farley, one of Bruce's inheritors, as the match for Marshall's shot. While Bruce, for all his outrageousness, stands at the mike with the authority of a professor, Farley grabs his mike with the fury of a rock star in extremis. The white backdrop makes him seems all the more unhinged, disconnected from any grounded reality, about to fly off into space, as huge as he is. He took advantage in grotesquely physical ways of the freedoms St. Lenny won, and he lost his life in the process. Both men died of drug overdoses.

"Lenny Bruce pushed boundaries of a medium and of society," White says. "Chris Farley pushed his own boundaries. He was such a physical comedian, and I think he was tortured that that's what he had to do. I worked with him a lot. On this particular day, he would get

worked up into a frenzy—eating and drinking at the same time that he was jumping around. Sweating profusely.

"In a very dignified, calm way, Lenny Bruce got in your face," he continues. "Chris Farley was the opposite. He got into your face in a big, broad way. But he had a sweetness and innocence too. He had that dichotomy, those two different sides."

In the case of another comic genius, Woody Allen, Marshall and White shot him decades apart, at very different points in his life and career. Marshall's shot of Allen huddled in a fetal position on a couch is itself a joke, a wry comment on the skittishness and neurotic fears that Allen transformed into an entirely new brand of subversive humor. "I took that shot in 1963 in a Washington, D.C., hotel room for the

Saturday Evening Post," Marshall says. "He was performing at a club there. He was one of the two or three top stand-up comics in the world. And there was an unknown schoolteacher–singer–piano player who opened for him that night. Her name was Roberta Flack."

By the time White shot Allen in New York thirty-one years later, much had changed. "This is a young man who is on top of the world, on top of his game, right here, when Jim met him," White says, pointing to Marshall's photo. "He hadn't yet achieved the financial success or the fame or the movies. He was a nebbish who was all of a sudden recognized as brilliant.

"When I got him, it was just after he broke up with Mia Farrow, and everything that followed," he continues. "All of the neuroses

and his autobiographical act culminated at this moment. When he got to my building, he wouldn't go up in the elevator because it was too small. So we had to bring him up in the freight elevator. He wouldn't walk out onto the roof because it was too close to the edge, so I had to deal with that.

"I took this shot for *Esquire*, and they wanted him to smile. No matter what. It wasn't a point in his life when that was what was going on. I had Soon-Yi help me get a smile out of him. I ended up getting two smiles: one in black-and-white, and one in color."

Match Prints ends on a personal note, with photographs of White's father and Marshall's mother. "That's Timmy's dad, who had quadruple bypass surgery," Marshall says. "And that's my mother. We stopped in a coffee shop in Tracy, California, on our way to her sister-in-law's funeral."

"I think what's more important about this selection is how it came about," White says to Marshall. "It was you. We were going back and forth, talking about images for this book, and you said something that I normally don't get from you—something emotional and personal. You said, 'I've got this picture of my mom that's kind of special.' And I said, 'Oh, I've got this picture of my dad.'

"But what I remember is…you can be a cool character," he continues. "You can put things out there that are hard and in your face a lot of the time. But this shows a sensitive

side to you that I didn't really know. I didn't really know that something like this would be important to a guy like you. But this is very important to you."

"It took my mother almost two and a half years to come to California from Iran, where she was born," Marshall says. "She went through what is now Pakistan, Afghanistan, Iraq, then to India, then to China, then to Japan, and then to here."

"Think about that will to get somewhere," White says. He looks at the two pictures. His father is ninety now. "They're survivors," he says. "And so are we, in a way. We're still here."

"Without them we wouldn't be here," Marshall says.

"To me, those are other people's heroes," he says, gesturing toward the stack of celebrity photographs we've been looking at. He taps with his finger on the picture of his father. "This is my hero," he says.

"And these are our children," Marshall says of the stack of photographs that make up this book.

White raises the question that inevitably comes up whenever artists put together a collection of some of their best work. "I hope this isn't all about glory days," he says. "I hope that's not what this sounds like."

"Well, it was my glory days," Marshall says with characteristic directness. "You've still got a lot to do. I think my best work has been done. I'm pretty much burned out. It's just not fucking fun anymore. I had such access, and to me it's insulting that I can't get that access anymore."

Times have changed. But that's not all bad. "I don't think Jim's glory days are over," White says. "I've learned a lot from him. His work has taken on a historical context, and people are really responding to it. We all relate to these people. This work that we've done resonates with people."

In the course of discussing the journeys of their careers as photographers, White and Marshall agreed that *The Family of Man*, the great book of photographs based on the 1955 Museum of Modern Art exhibition curated by Edward Steichen, inspired them, and was perhaps the most important book of photographs ever published. In that sense, it's appropriate that this discussion of *Match Prints* concludes on a familial note. Jim Marshall and Timothy White are colleagues, brothers, father and son. They are blood.

And for all the celebrity of many of its subjects, this book explores the shared humanity of those people as well. It depicts rises and declines, truths and falsities, genius and tragedy, joy and exhilaration. Many of the visual stories in here trace their arcs over decades. *Match Prints* is about an enduring spirit—within both the subjects and the images that chronicle them.

And it depicts the endurance of the relationship between Marshall and White as well. "We talked about *Family of Man*," White says. He points to himself and Marshall. "This is family too."

"And you don't fuck with family," says Marshall.

"I love photography," White goes on. "And I love the idea that here's two people who are

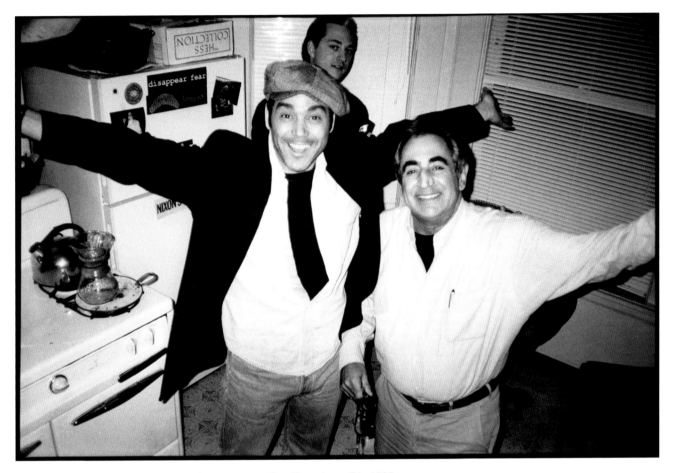

Self-portrait of Tim and Jim at Jim's apartment, San Francisco, CA, 1999.

completely different. Different ages. Different styles. Different schools of thought. Different cameras. Different film. Different approaches to the whole thing. But we want to put our pictures together. It's not that they belong together. It's not even that they work well together. It's just that we want to do it. We want to find this place where we overlap in our lives."

And where they overlap with the lives of the millions of people, their extended family, who have looked at these photographs and been thrilled.

—Anthony DeCurtis

PLATES

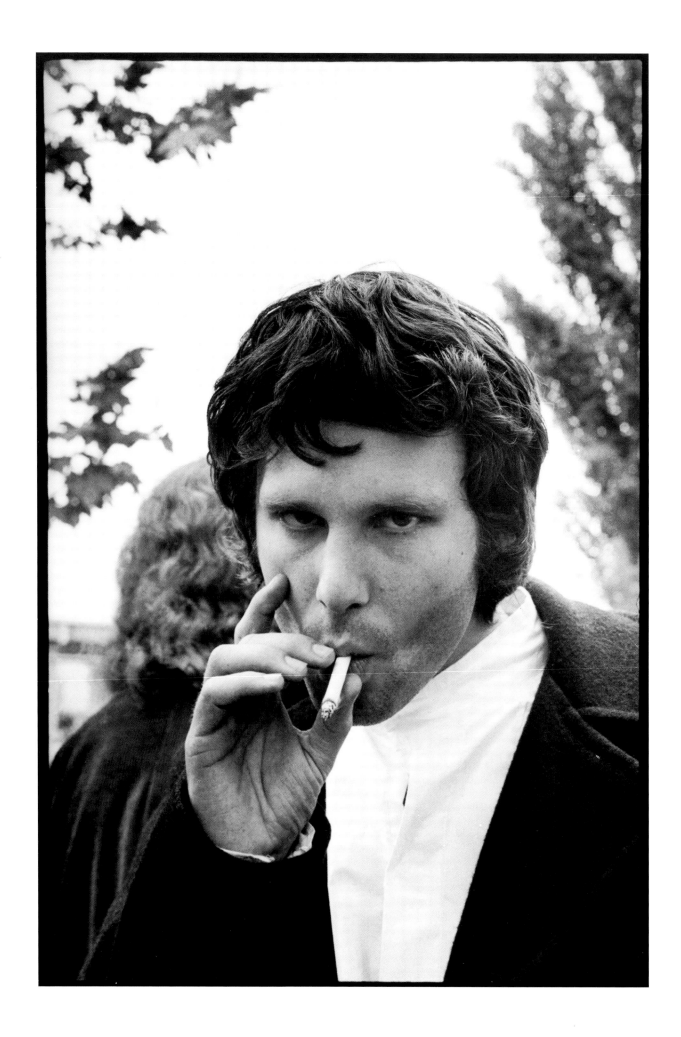

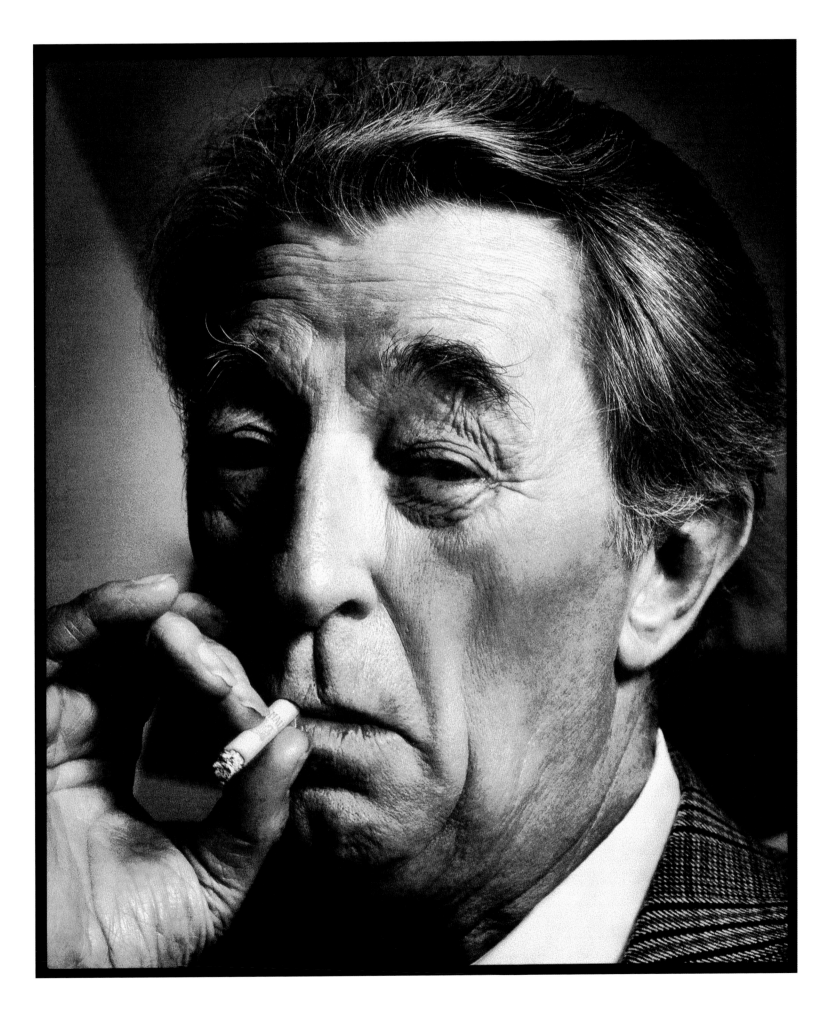

Mitchum/Morrison: two kings of bad boy cool, cut from the same magician's deck, potent symbols of their respective generations' most rebellious yearnings. One captured in his prime, one on the precipice of his decline. Both were poets: Morrison's roots were in verse, while Mitchum's earliest ambition was to be a writer: he had childhood poems published, short plays produced by the Player's Guild of Long Beach, even an oratorio produced by Orson Welles at the Hollywood Bowl. Both were musicians: Mitchum played the sax, wrote songs, and recorded a country album, a kitschy calypso album, and unreleased duets with Dr. John, Marianne Faithfull, and Rickie Lee Jones. Both were filmmakers: early on, Morrison directed a documentary and a short film; Mitchum produced *Thunder Road*. Both were actors: Morrison's stage theatrics were as riveting as Mitchum's most nuanced performances. Connoisseurs of excess, each wrestled demons spawned of sensitivity masked by machismo, and each struggled to maintain equilibrium amid the merciless demands of fame.

Study the faces: the seen-it-all eyes, predatory and wary, staring straight through the lens into your soul. Who would guess the handsome young rock god would be the first to fold just three years after Jim Marshall took this iconic photo? That the war horse daring Timothy White to capture his essence would soldier on for nearly another decade before his ruined lungs collapsed? Searching for my youthful father's extraordinary beauty in this unflinching portrait, it is tempting to imagine how Morrison's face might have morphed to match the craggy decadence of Mitchum's sixty-nine hard-won years. Match prints, indeed.

—PETRINE DAY MITCHUM

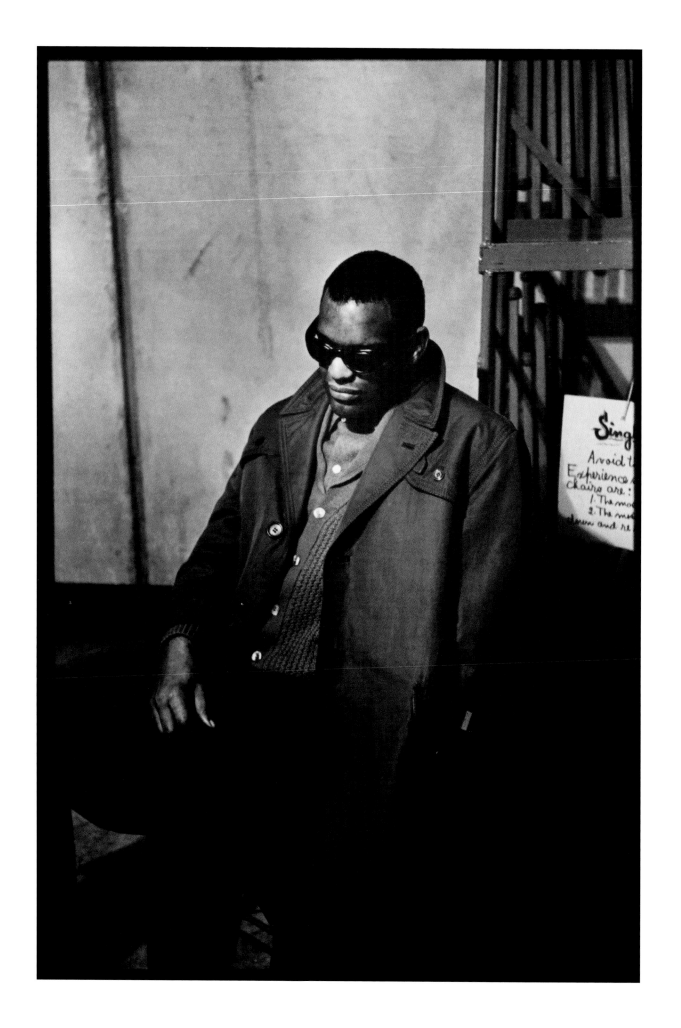

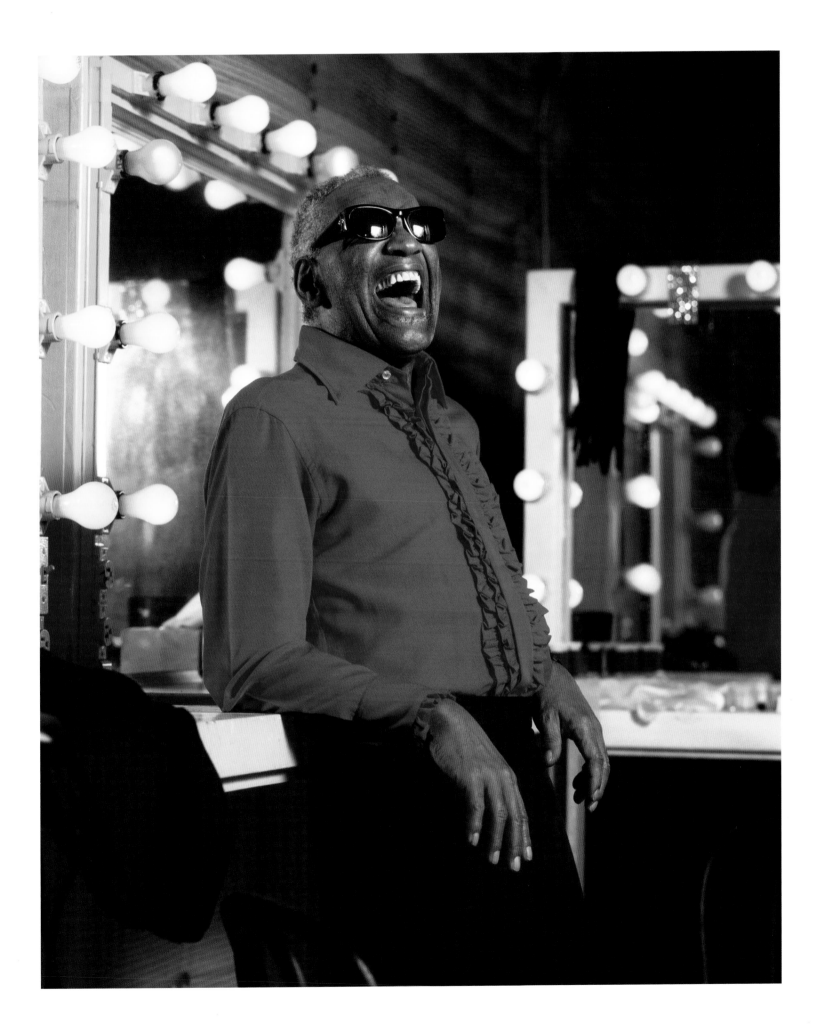

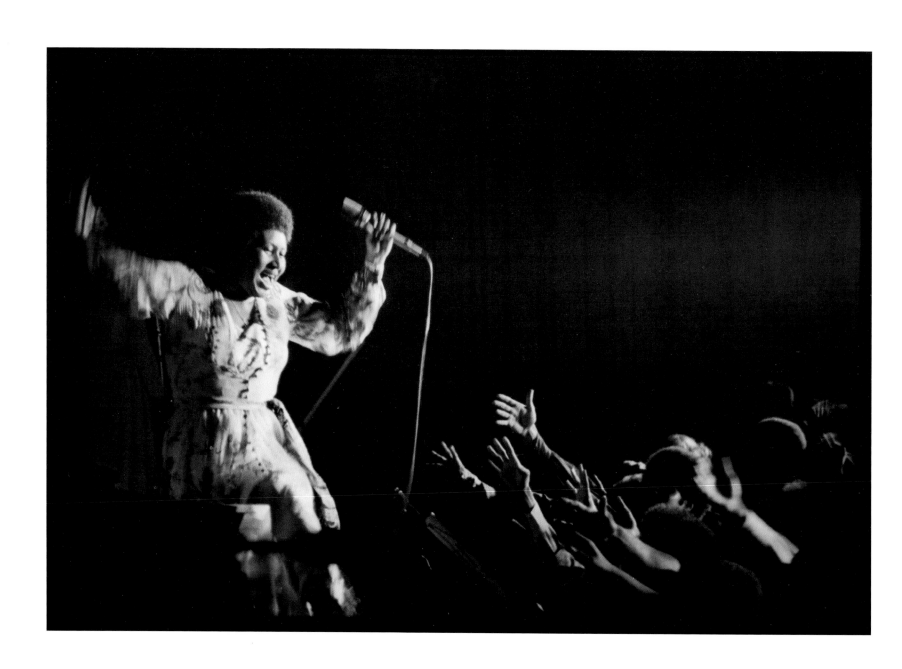

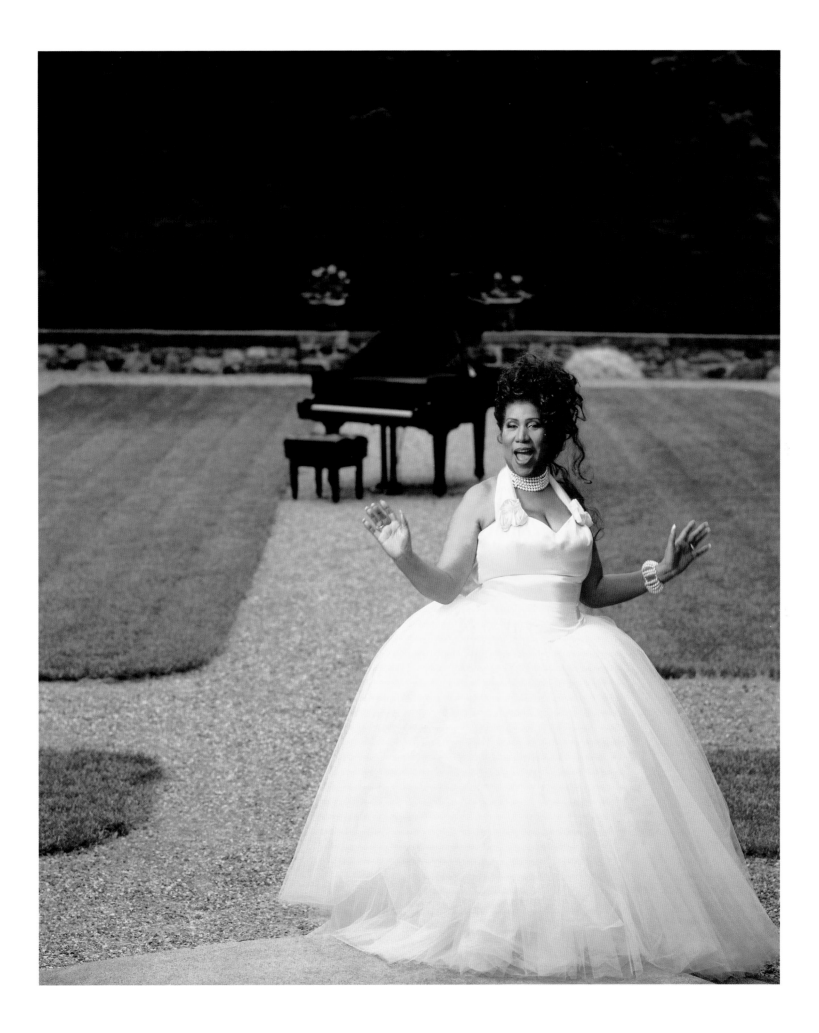

With Timothy it is all in the eye. When we work together, I just know he sees the moment and he gets the shot. I trust Timothy, and our sessions are always natural.

—ARETHA FRANKLIN

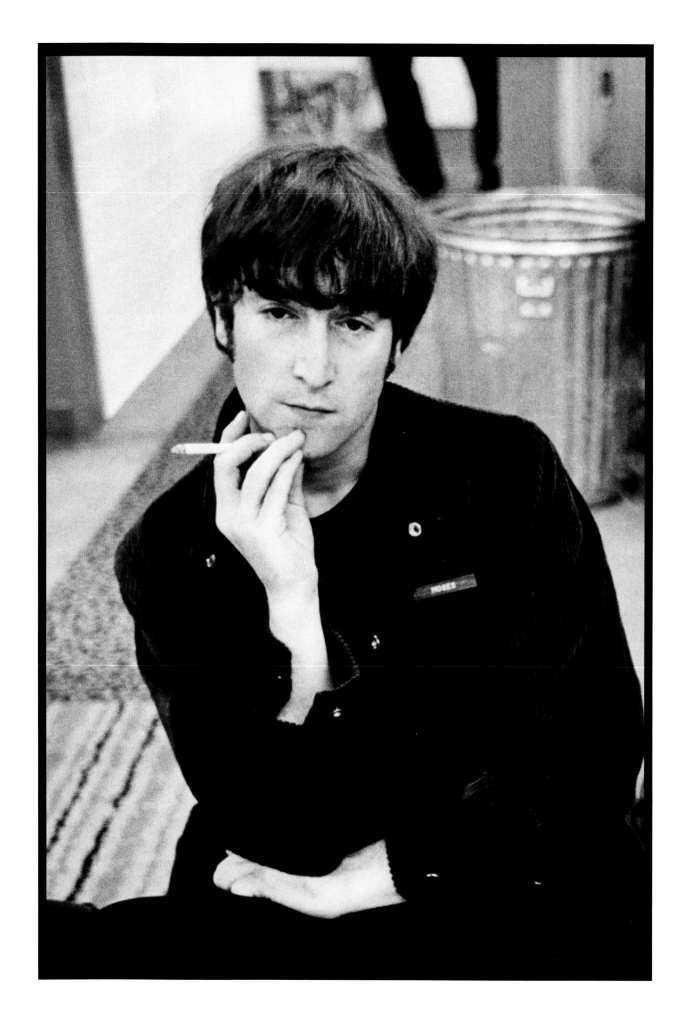

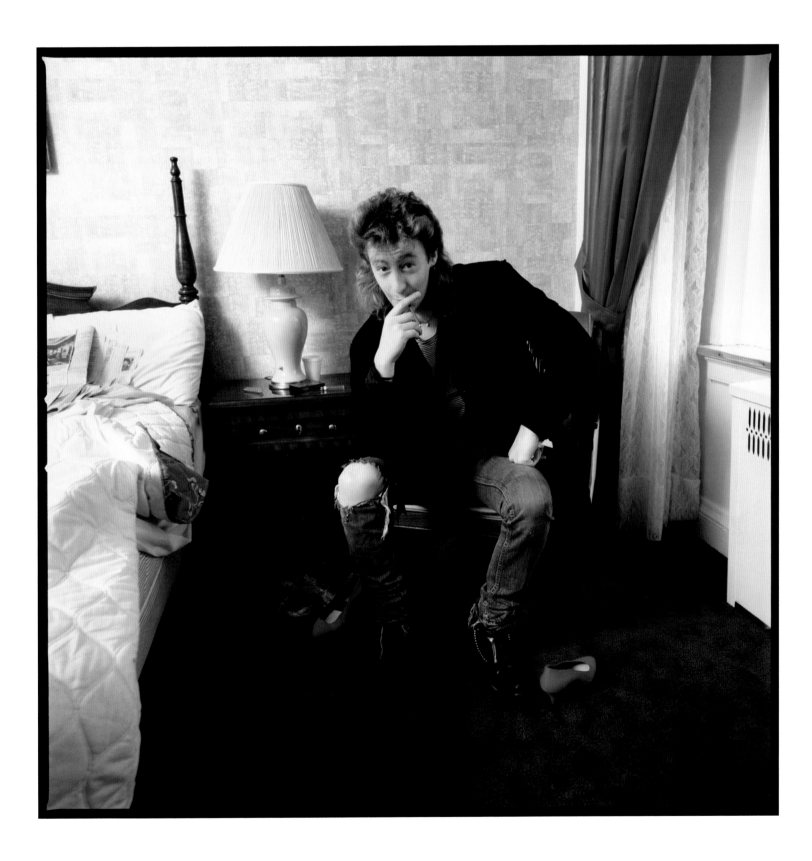

I have worked with many excellent photographers over the last twenty years or so, Timothy included, but he is one of the only photographers that I know who is able to really capture the essence, strength, and fragility of his subjects, whether they like it or not! Which I believe is what makes an incredible photographer, as well as someone who really cares about presenting our past, present, and future icons in a most raw and honest way.

—JULIAN LENNON

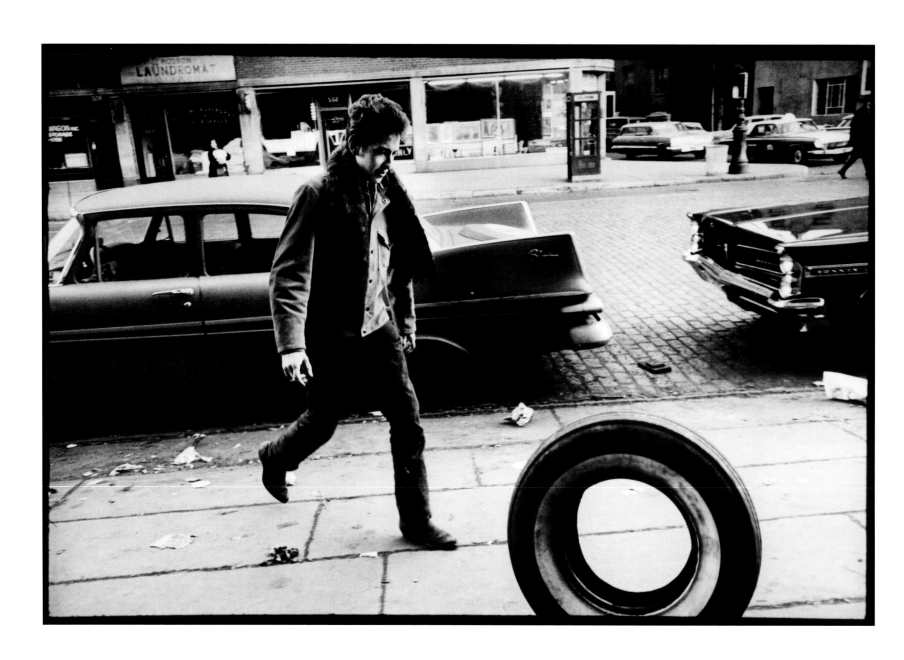

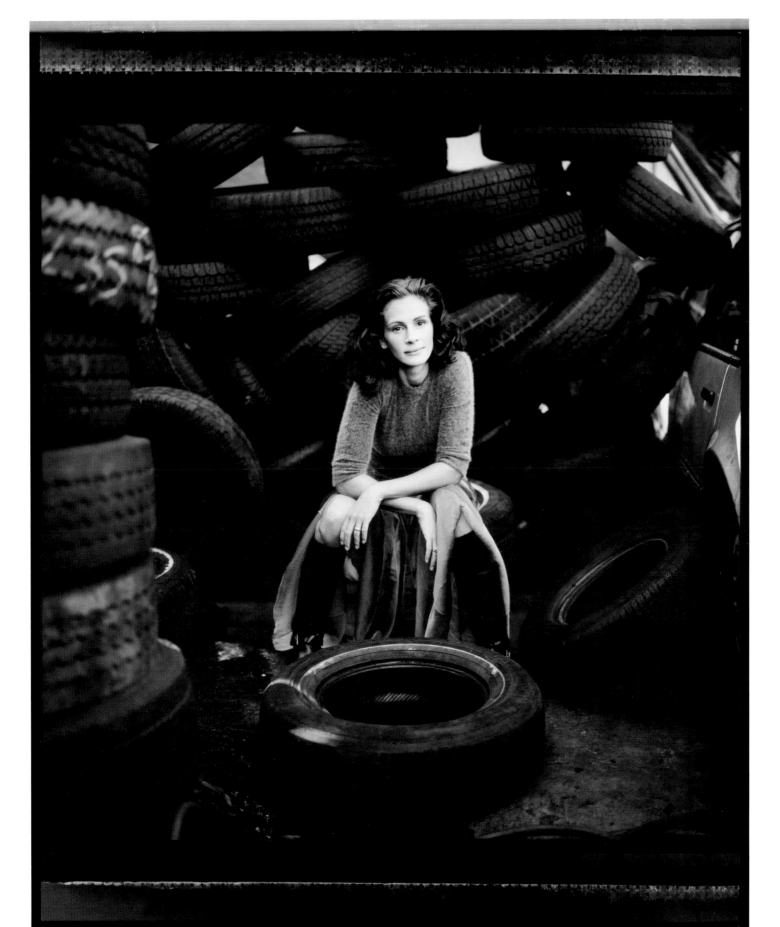

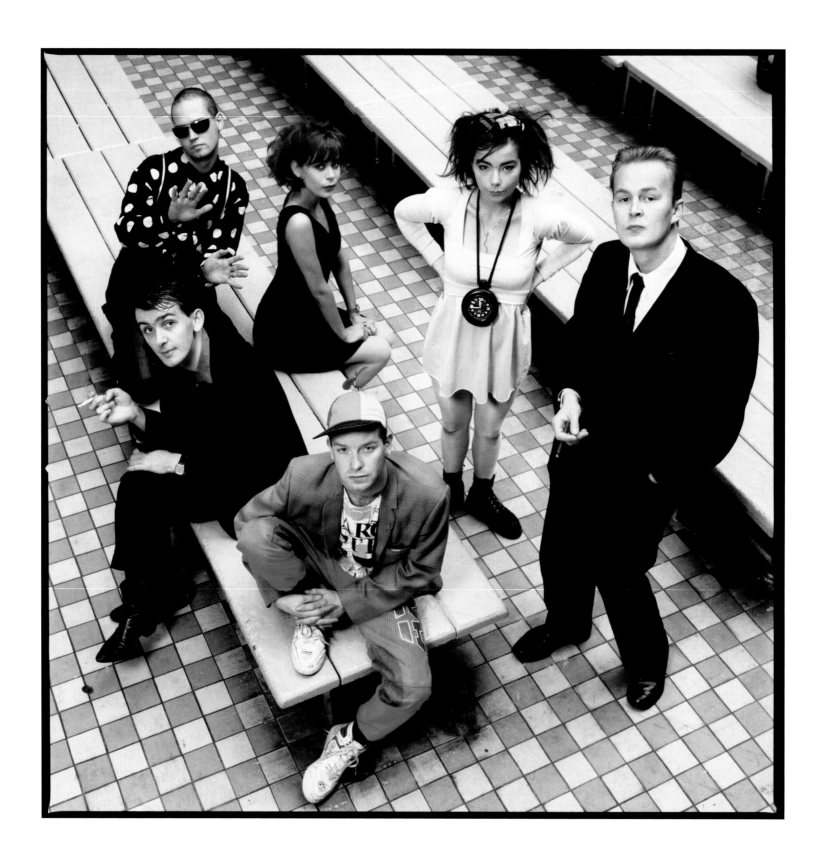

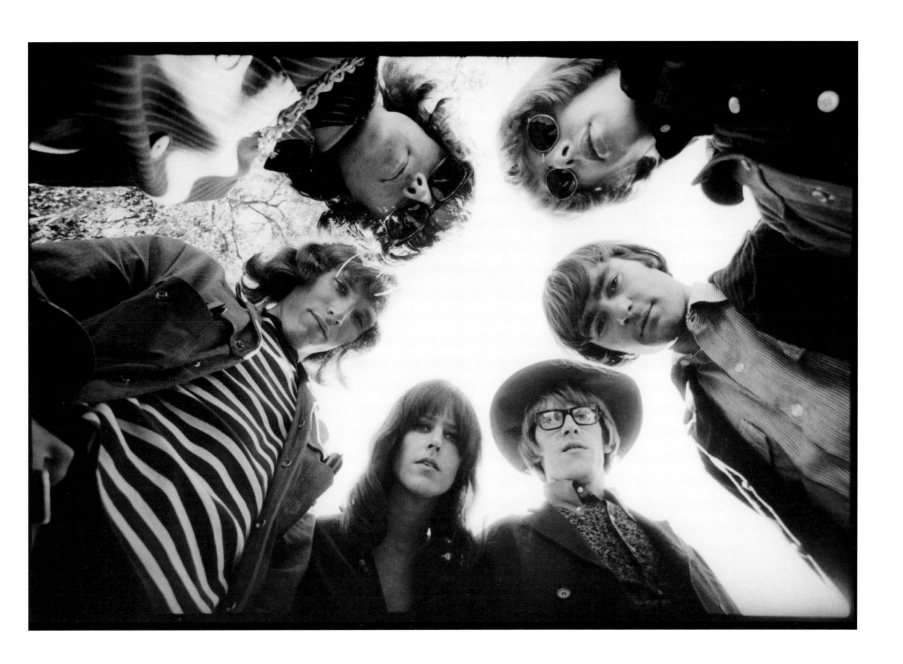

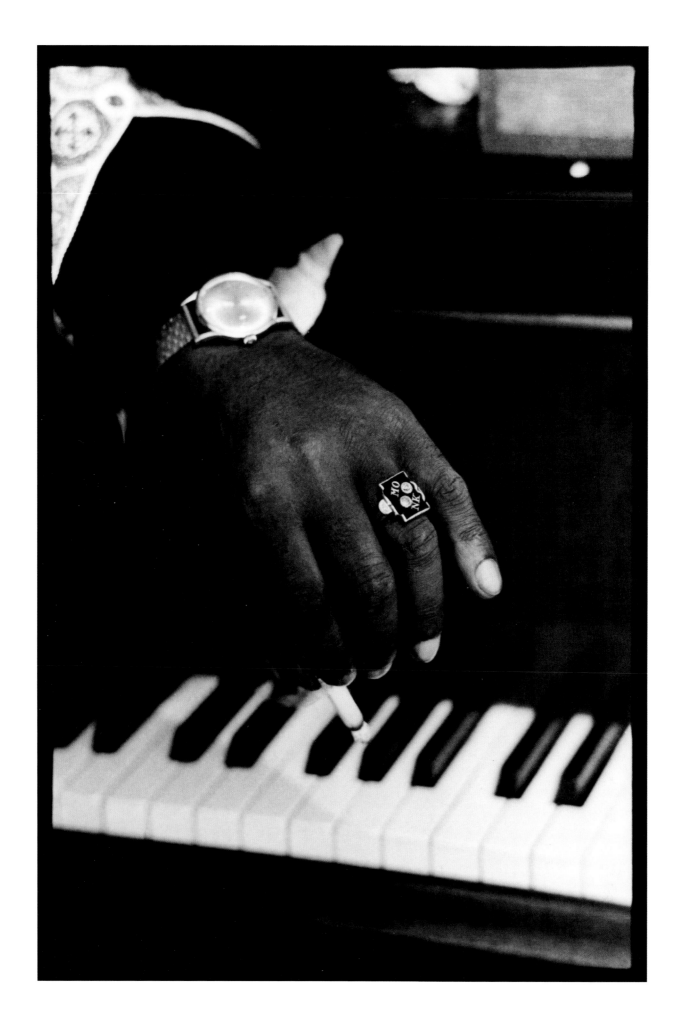

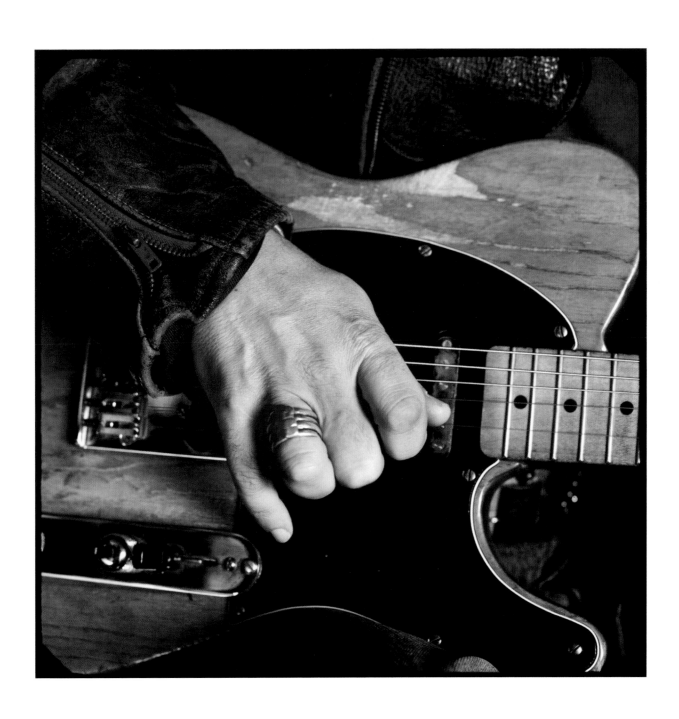

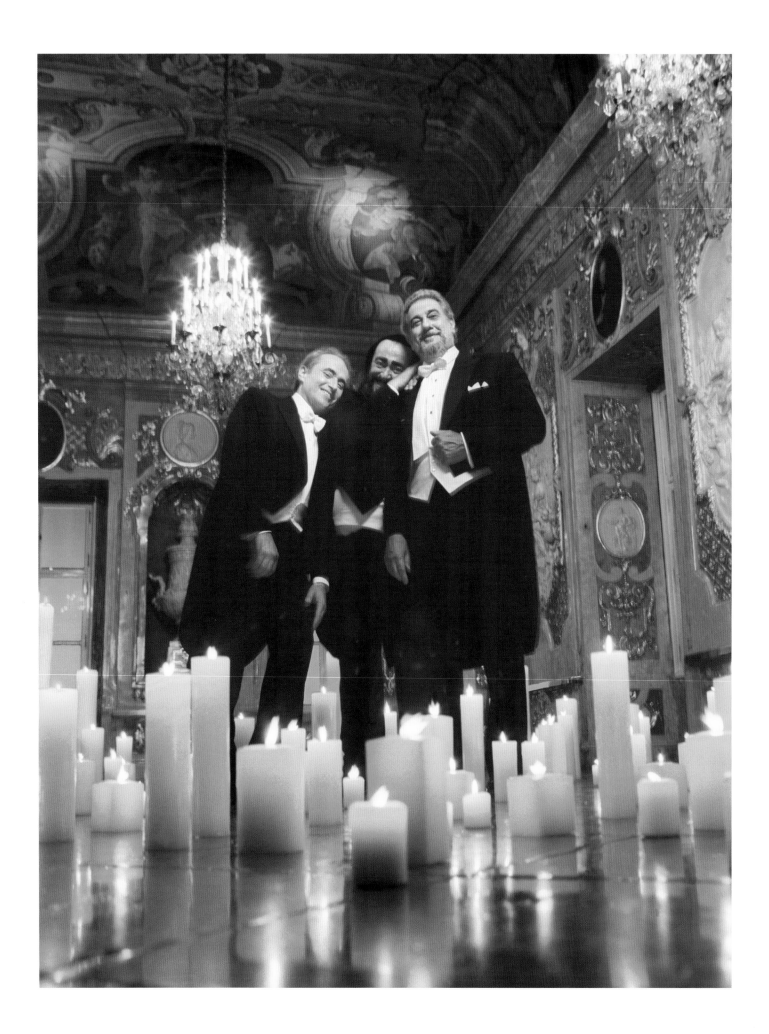

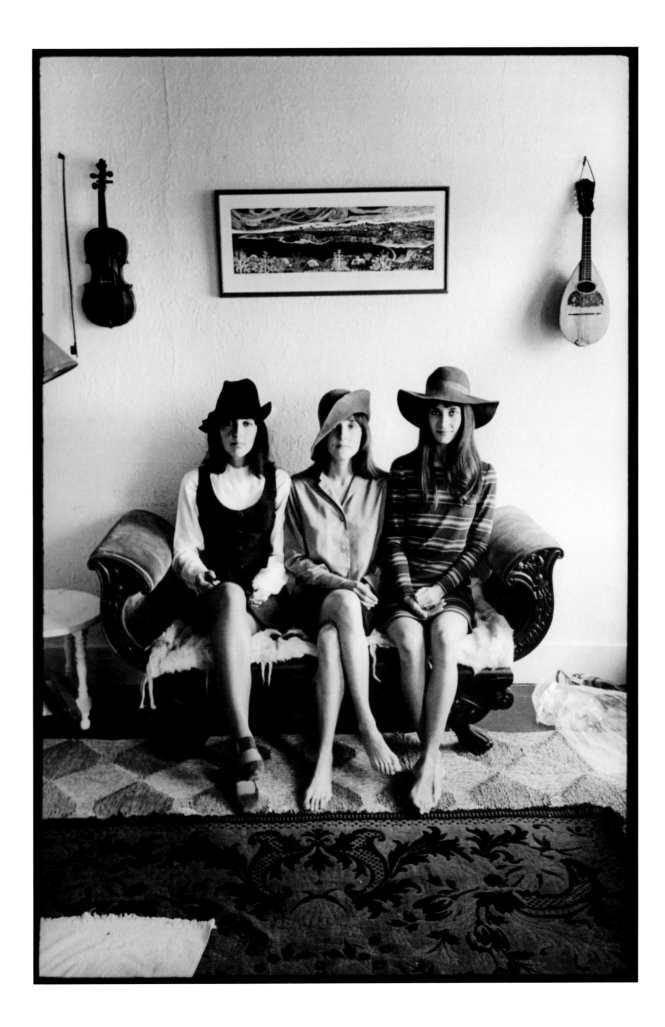

Jim Marshall has photographed me more times and for more decades than any other photographer. Not always a joy to work with, Jim is quirky and bullheaded like me, which is probably why we have remained close friends for so many years. His work continues to bring us joy and amazement.

—JOAN BAEZ

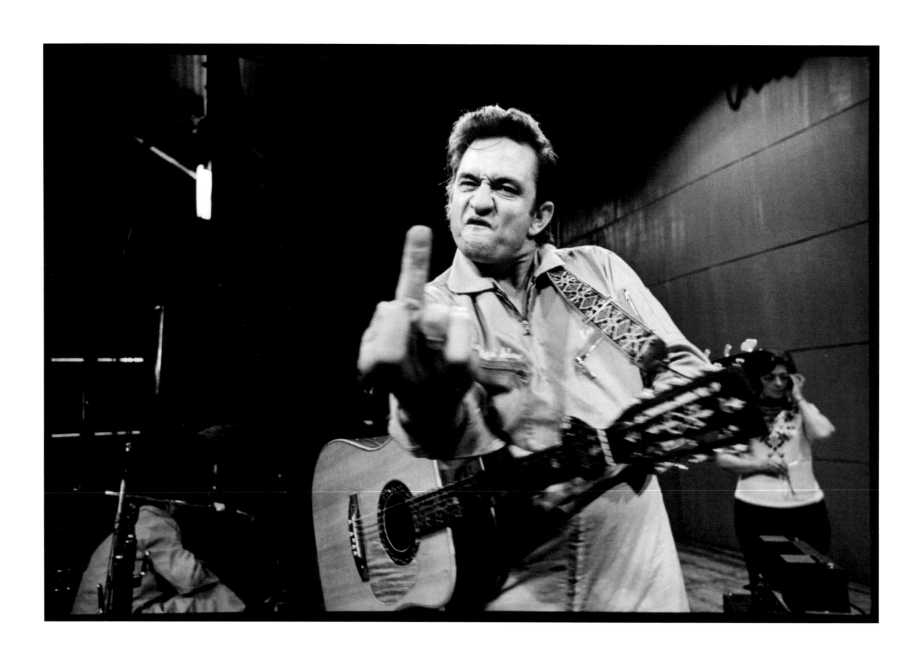

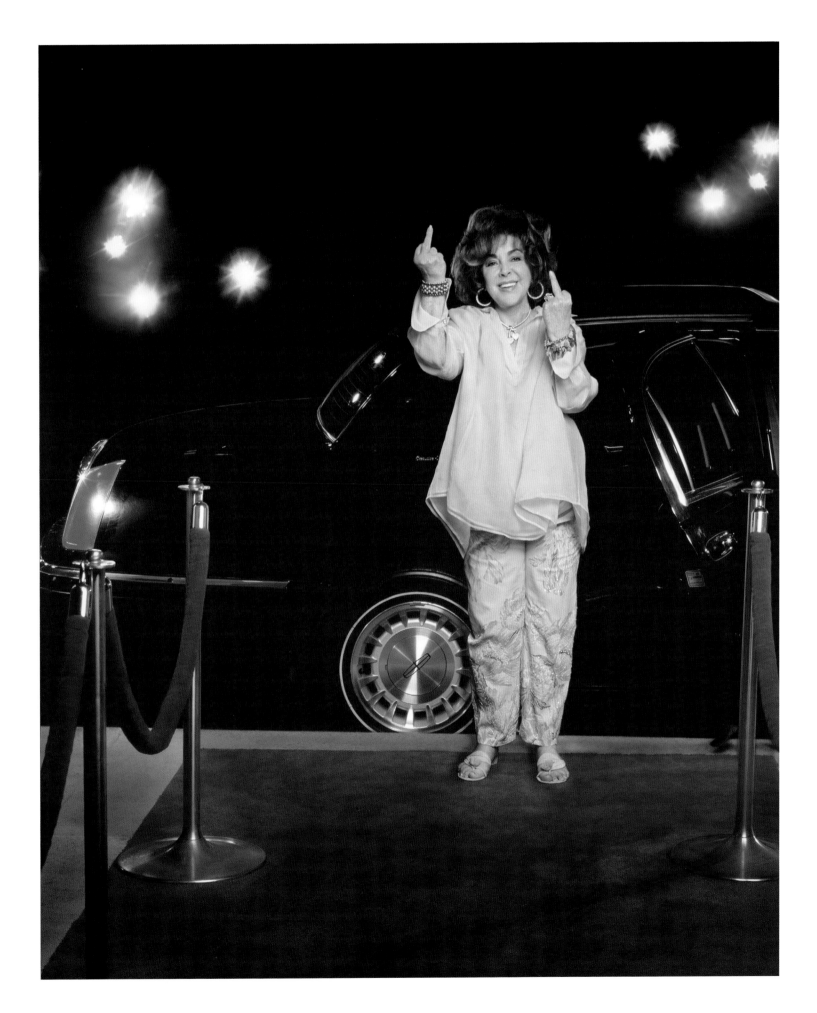

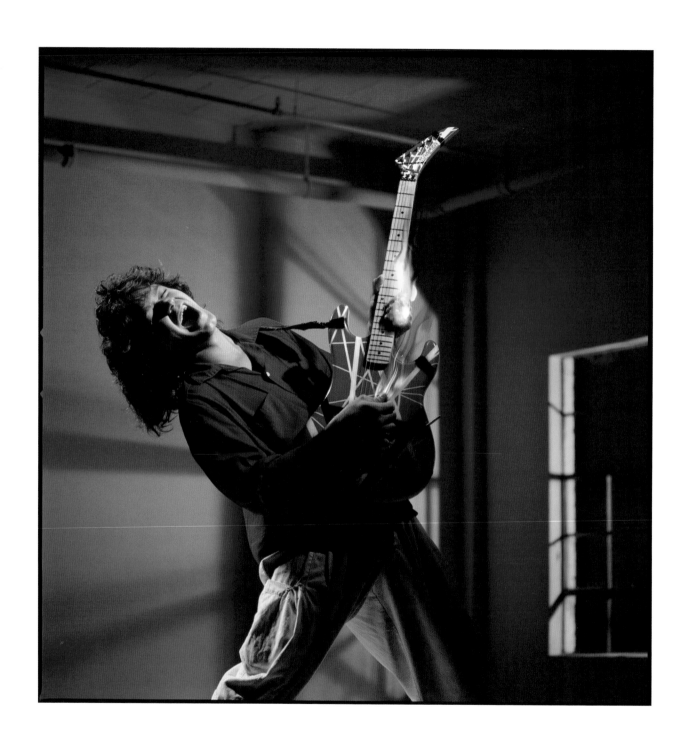

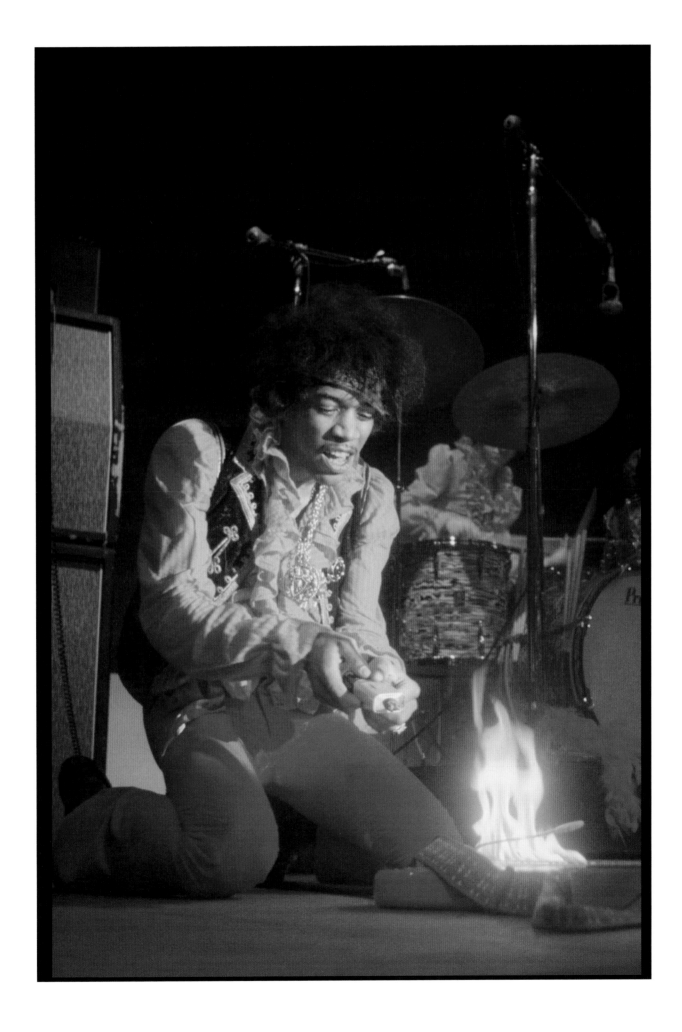

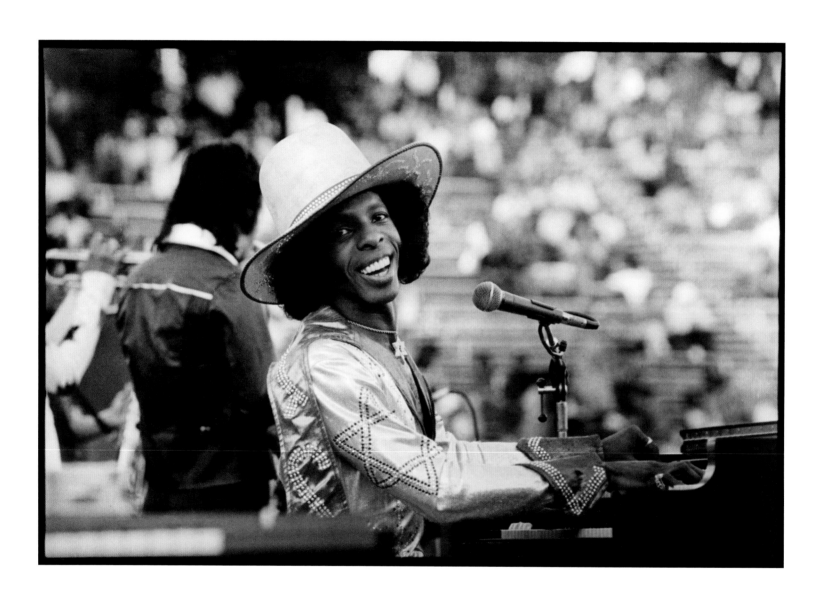

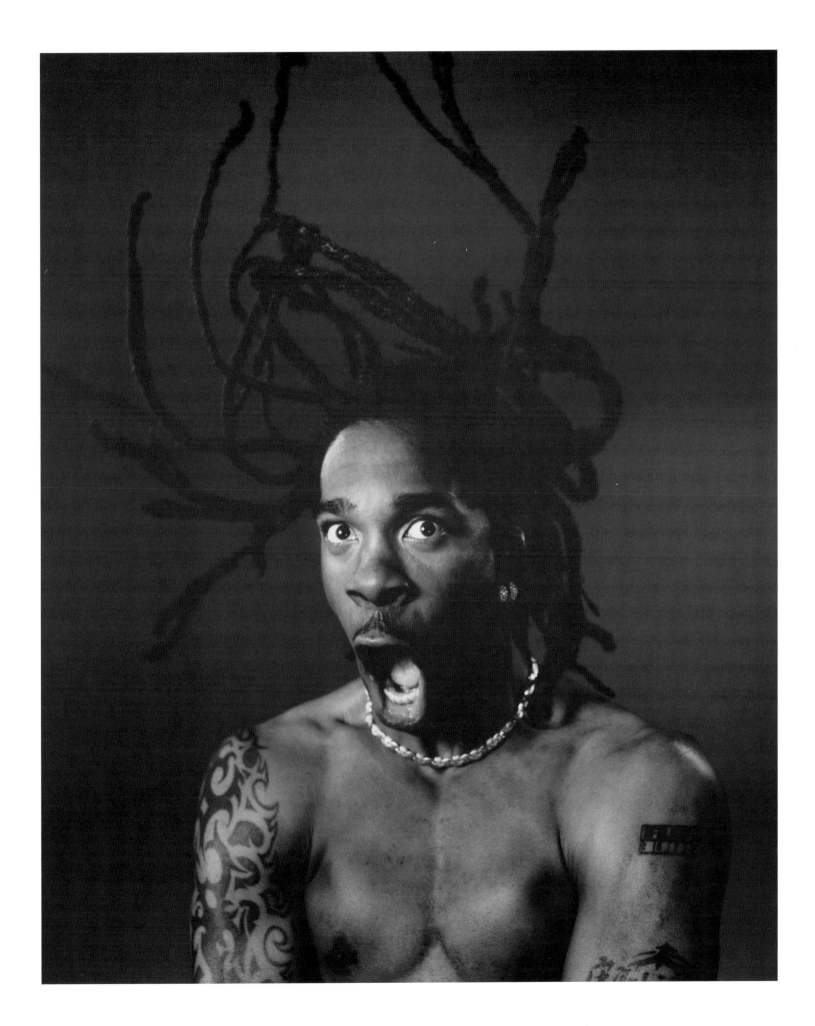

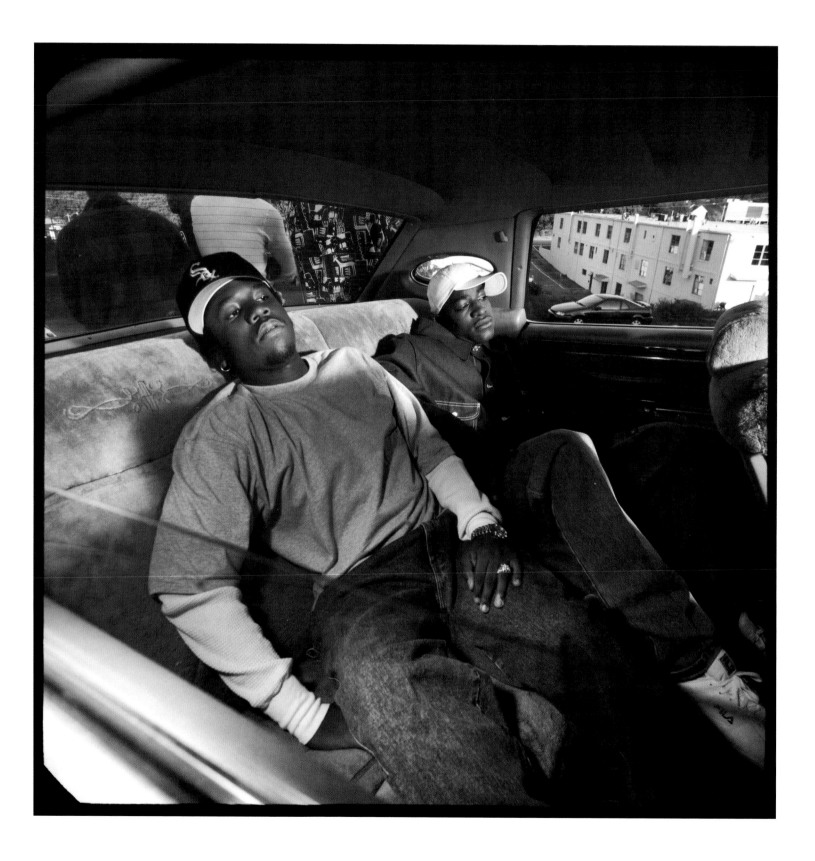

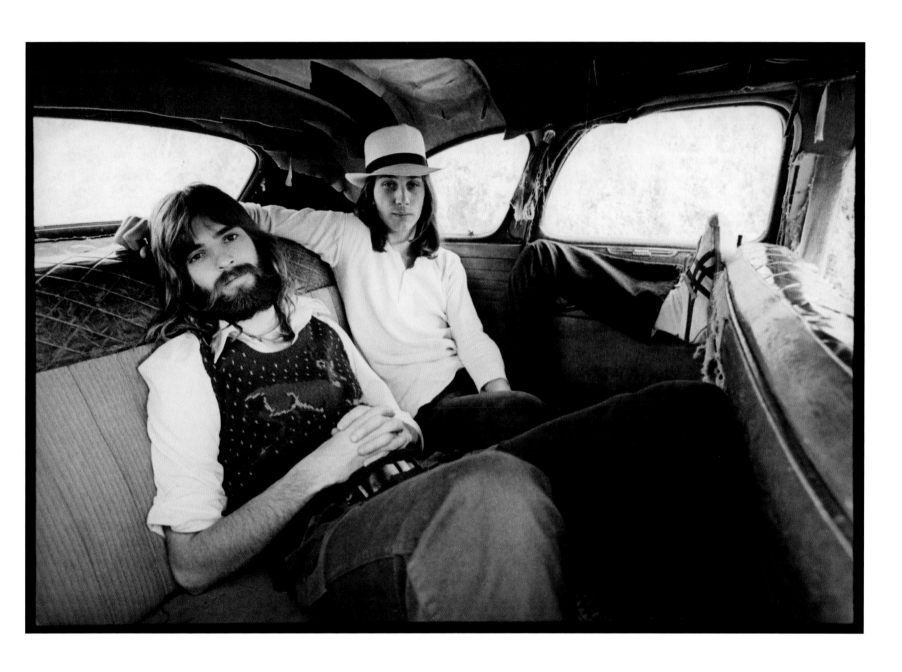

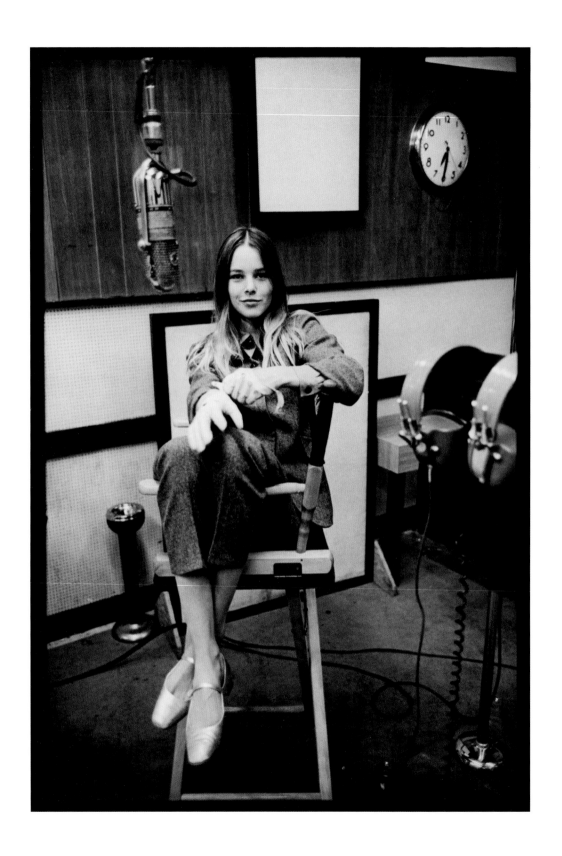

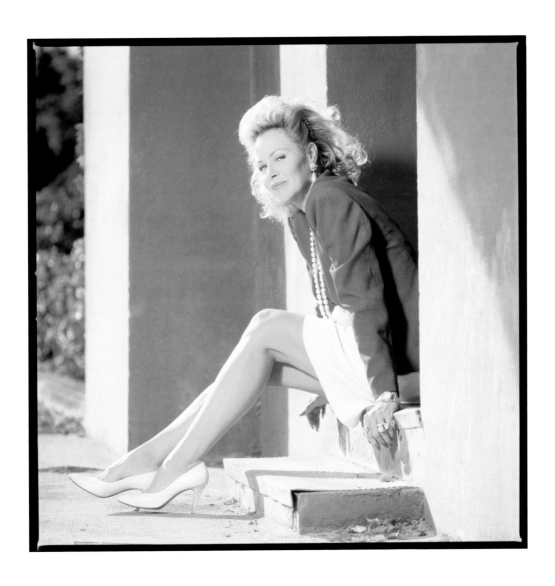

Jim was such a great photographer because I never knew he was there. I mean this as a compliment. He was the perfect fly on the wall, never in my face. I would be surprised when I saw some of this great work because I didn't realize he was taking photos until afterwards.

—MICHELLE PHILLIPS

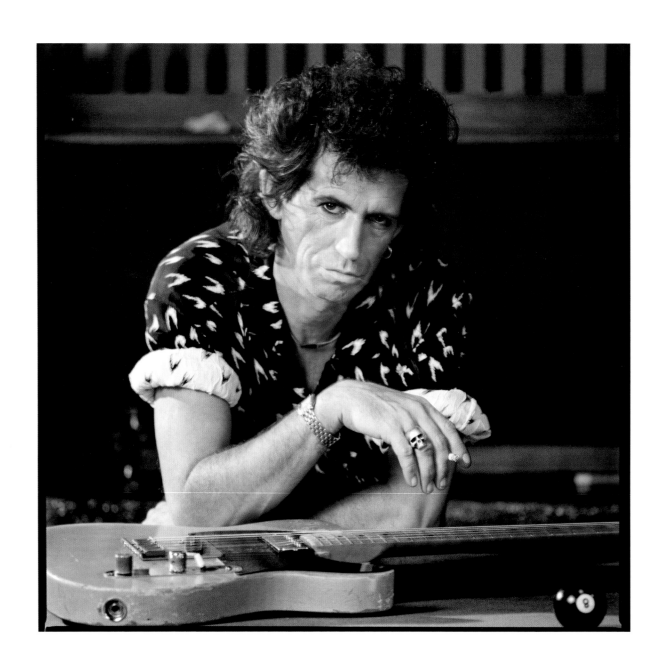

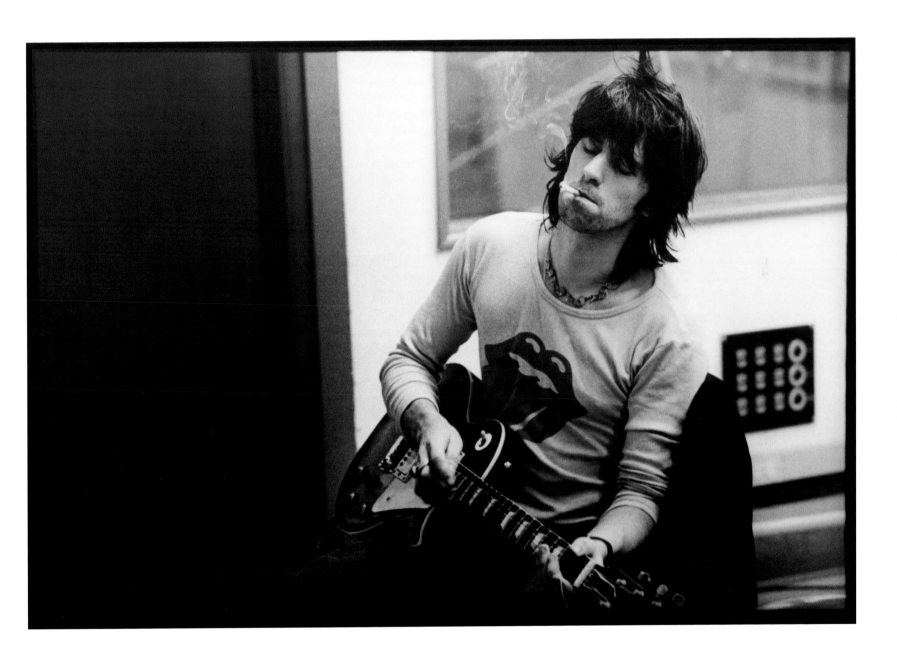

This is looking at a guitar and thinking about it. This is playing it!

—KEITH RICHARDS

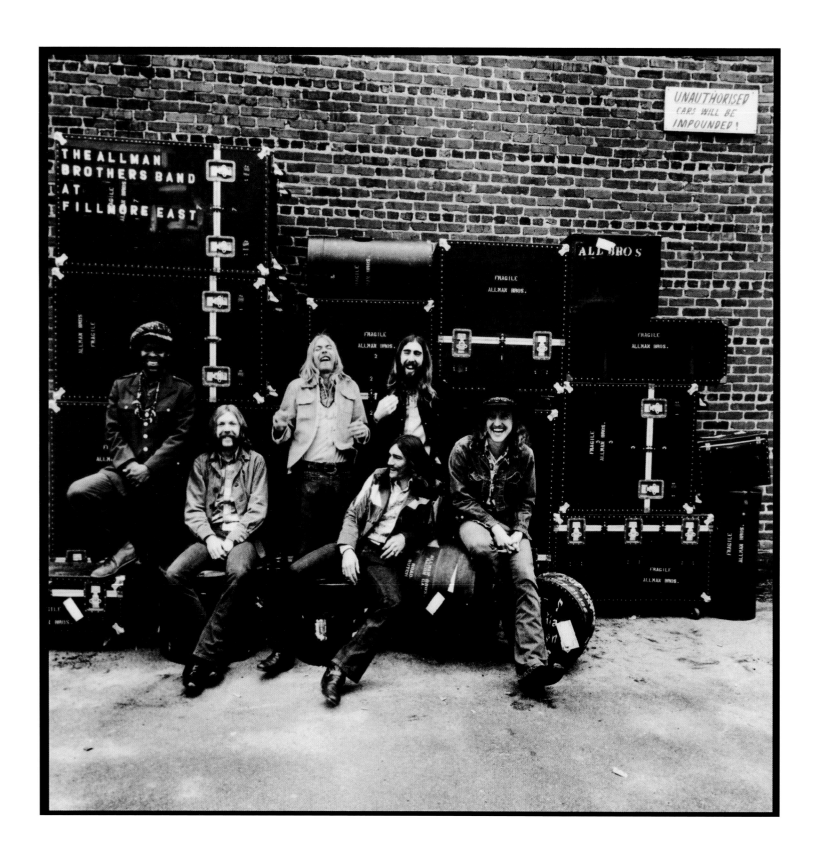

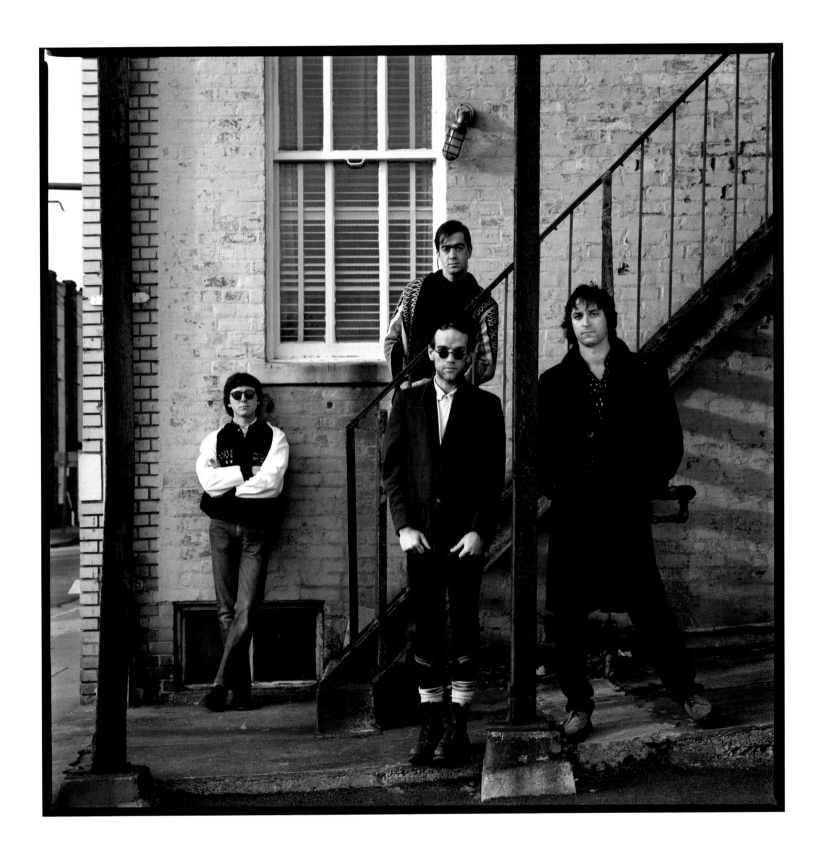

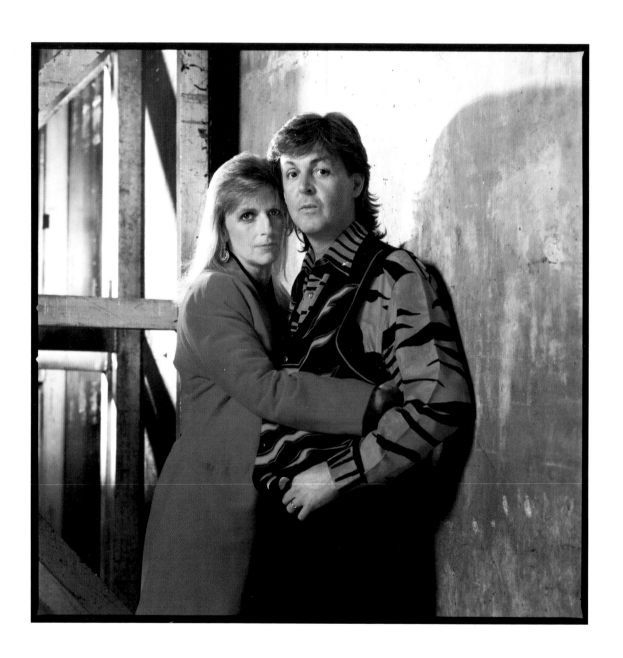

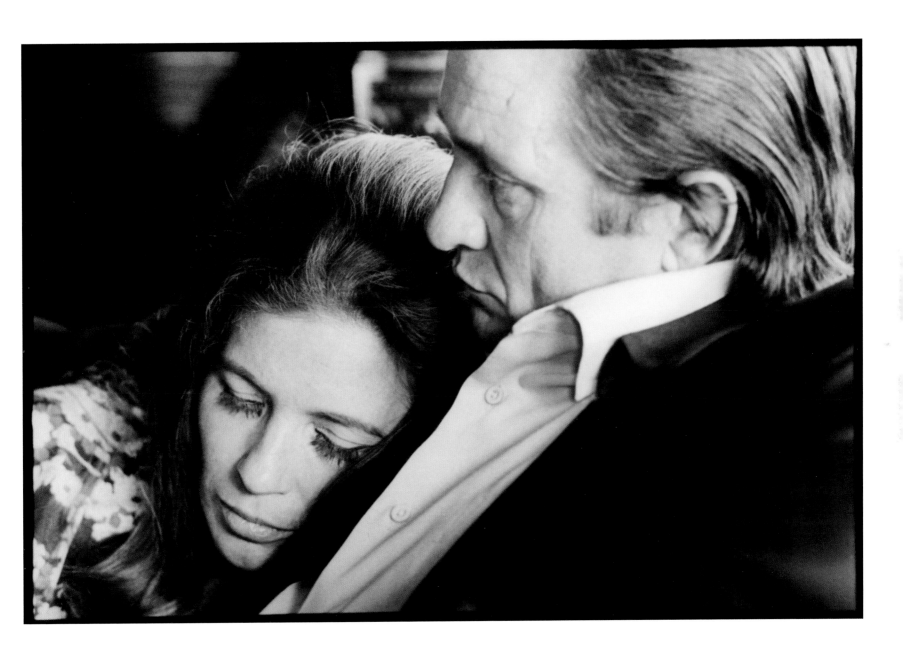

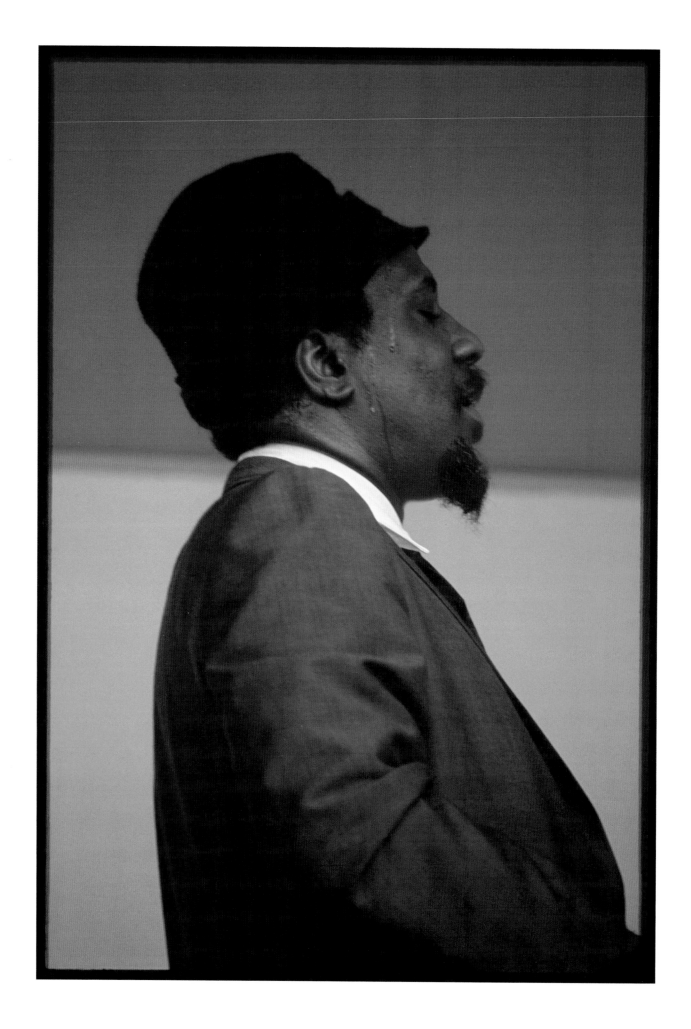

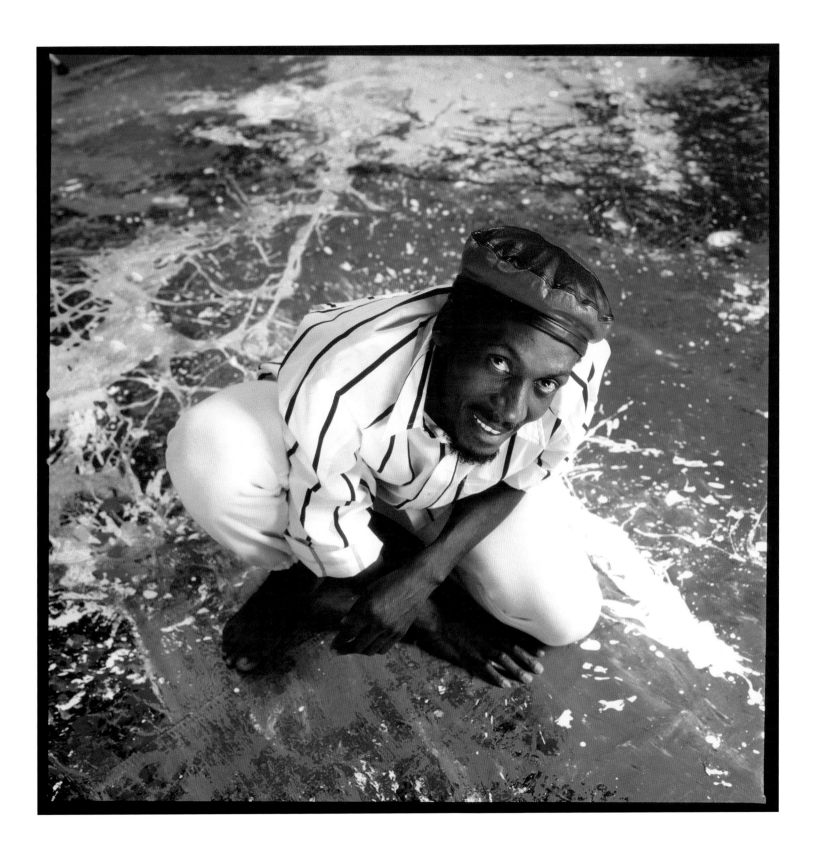

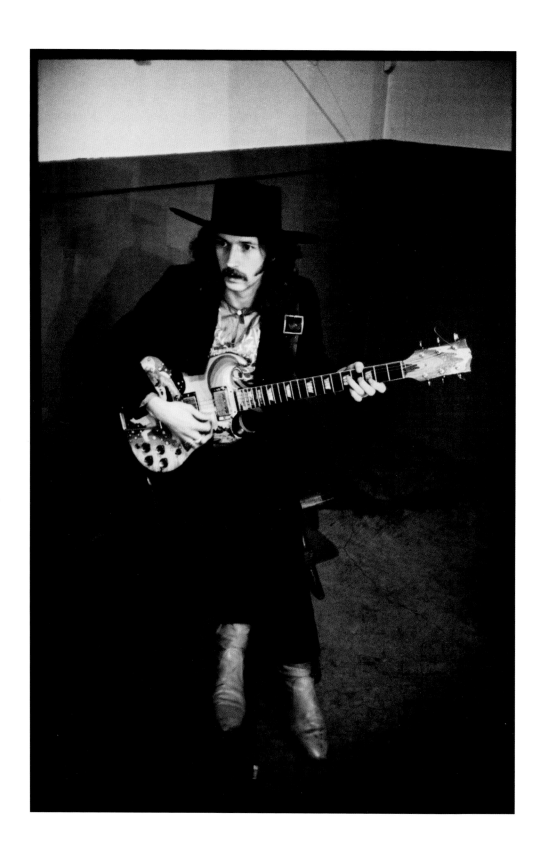

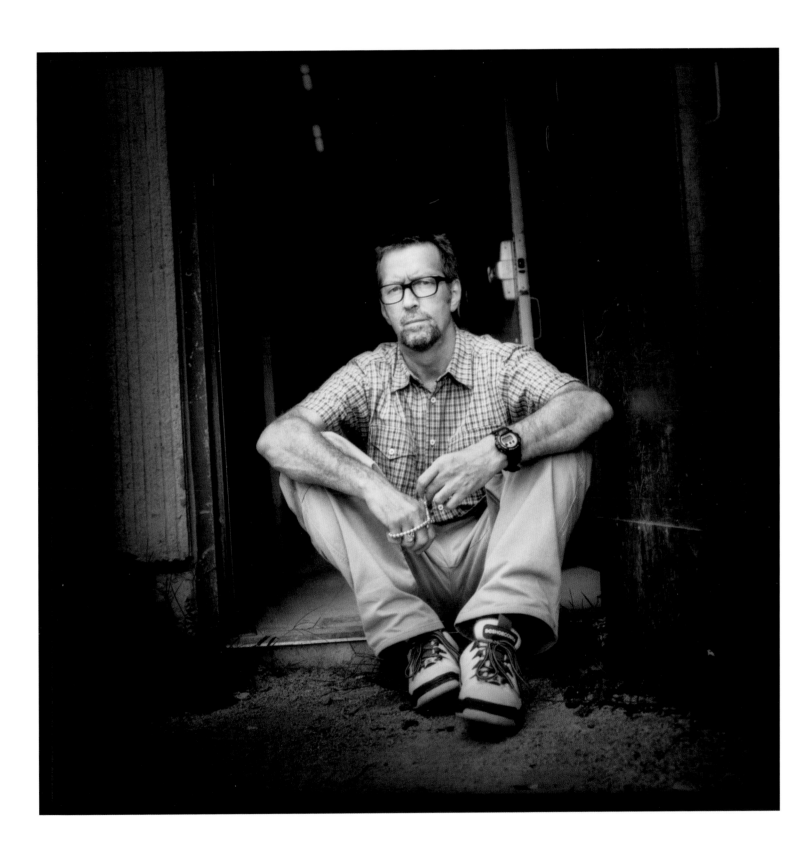

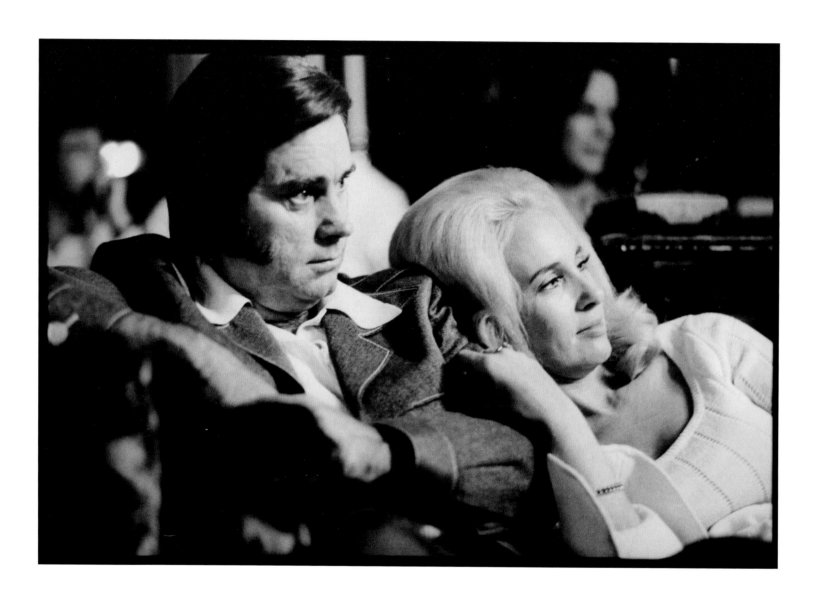

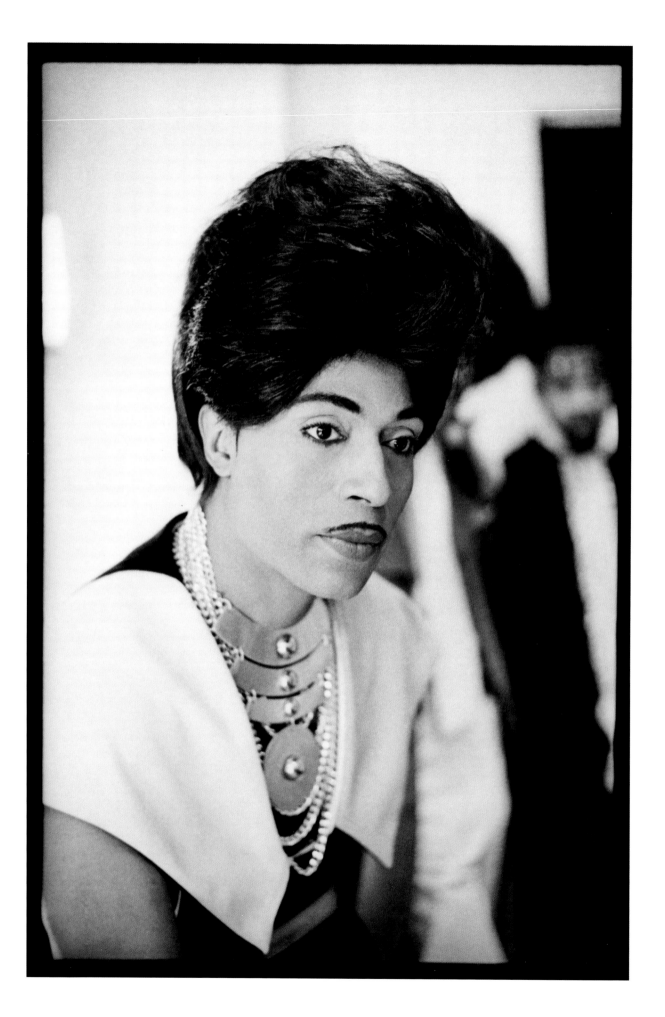

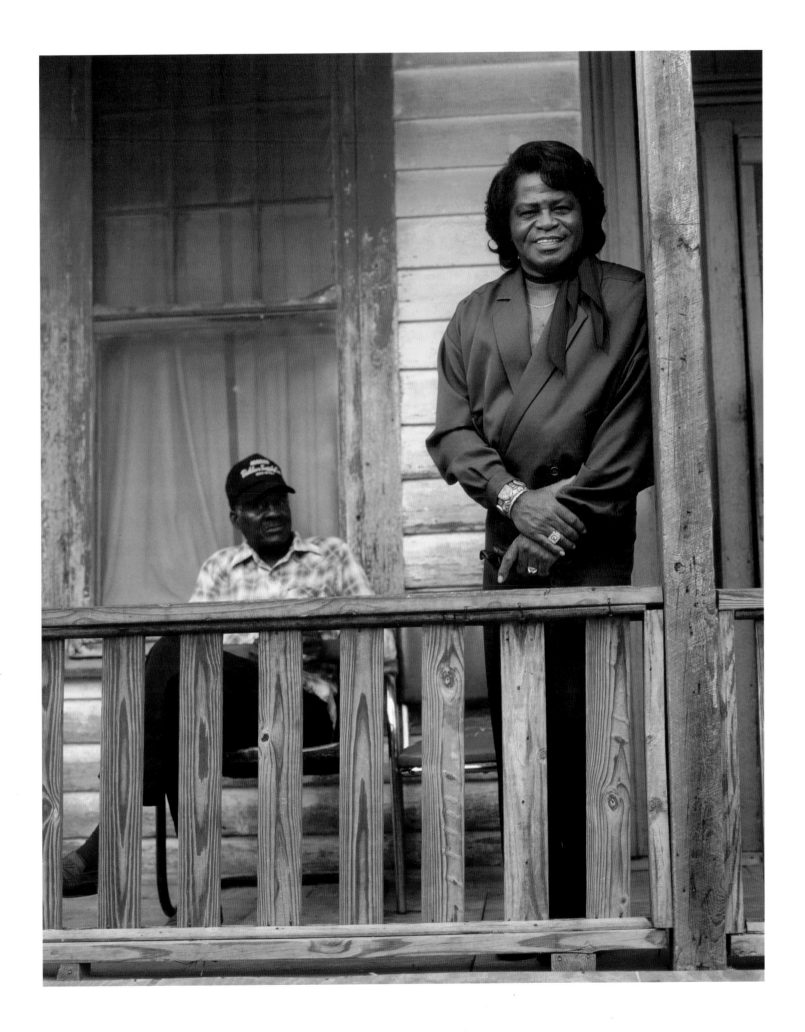

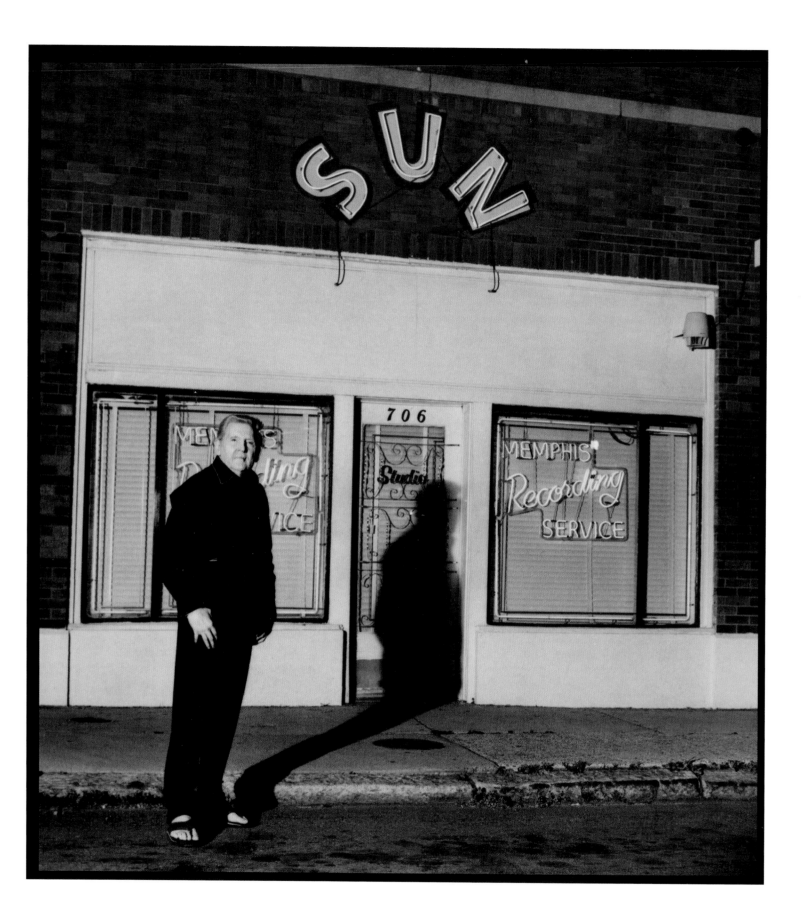

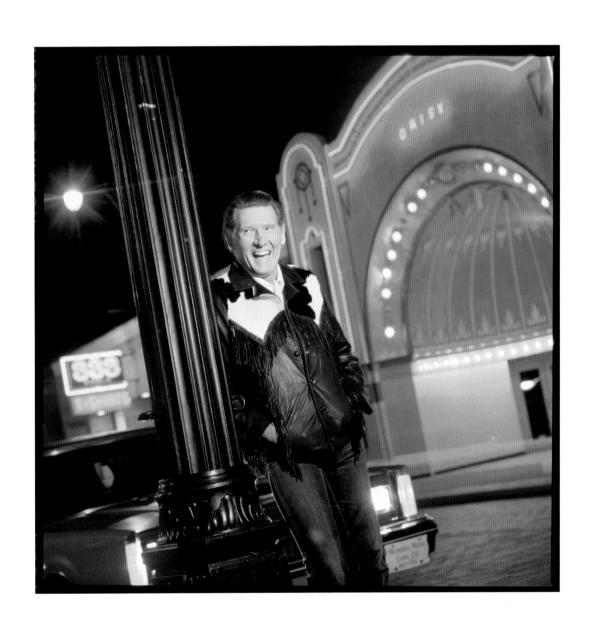

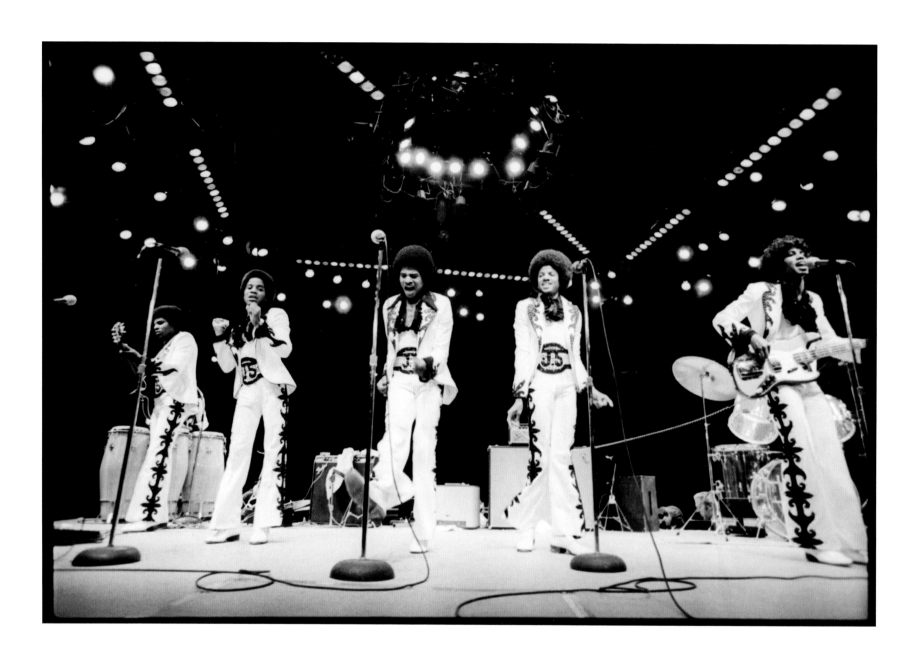

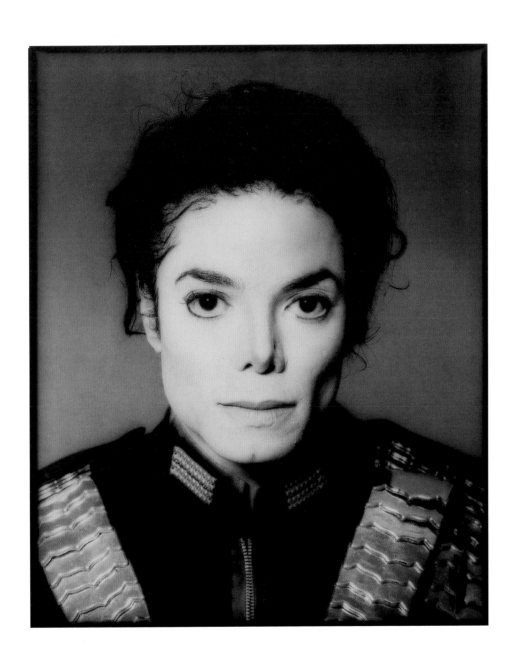

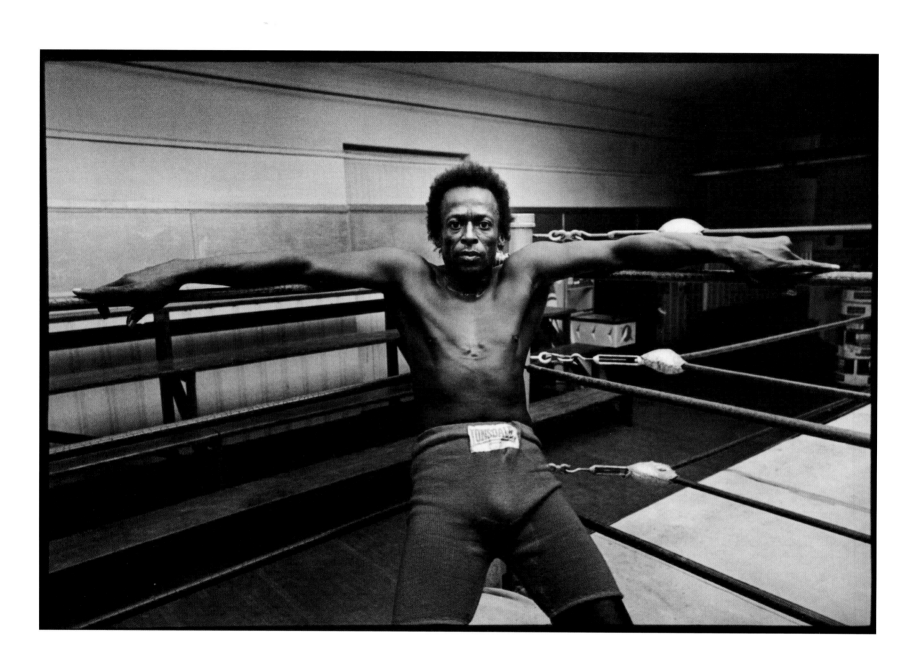

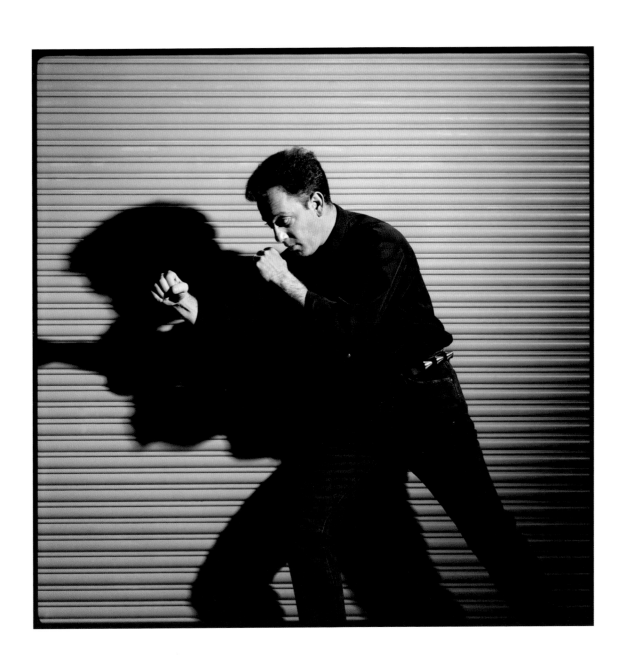

My father always says: "Find one thing you love doing, and just keep doing it 'til your fingers bleed—just *one* thing is all you need to be complete." He always puts it so simply, just like that. But I can tell he *means* it. He's lived by it his whole life, so he's earned the right to own those words, you know? Of course, he also (publicly) says, "Don't take any shit from anybody," but I think he's just trying to be a tough guy with that one; when his true colors are revealed, he has a soft, vulnerable heart, and I think that quote is his own personal form of protection. I think my Dad still can't believe that he was this poor kid from Hicksville, and now he's a living, breathing, rock 'n' roll legend. Most people don't look that far into it, but because I'm his daughter I can tell he's still in awe of the whole thing. That's why he's still out there, playing shows, decades upon decades after he's already "made it": he has to, to constantly prove to himself that this is his reality, this dream actually *happened* for him. Maybe one day it will all sink in, but I find it kind of endearing that he's still surprised by the whole thing; rarely do you find that kind of humility in a wealthy, successful man!

—ALEXA RAY JOEL

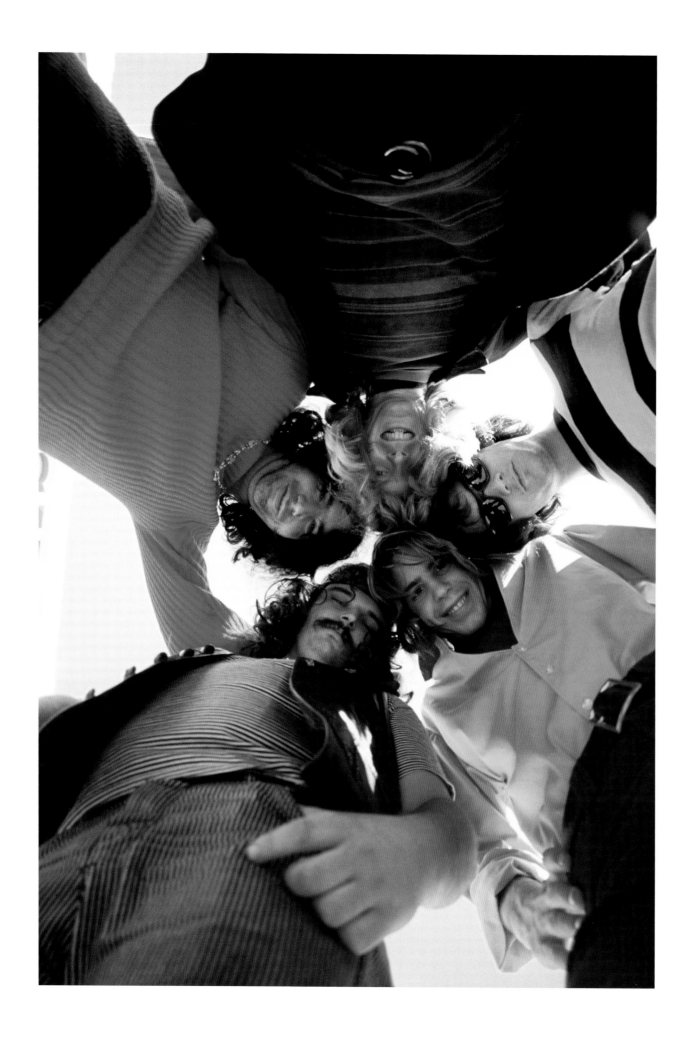

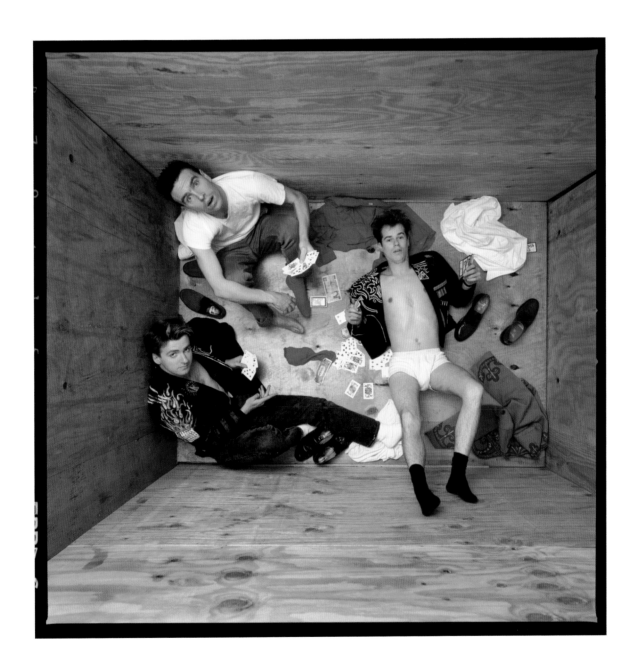

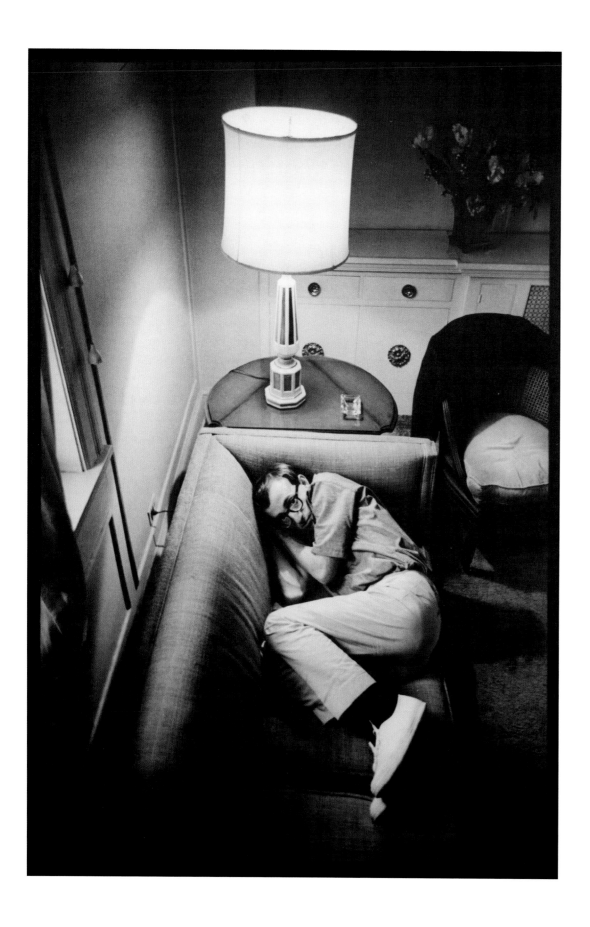

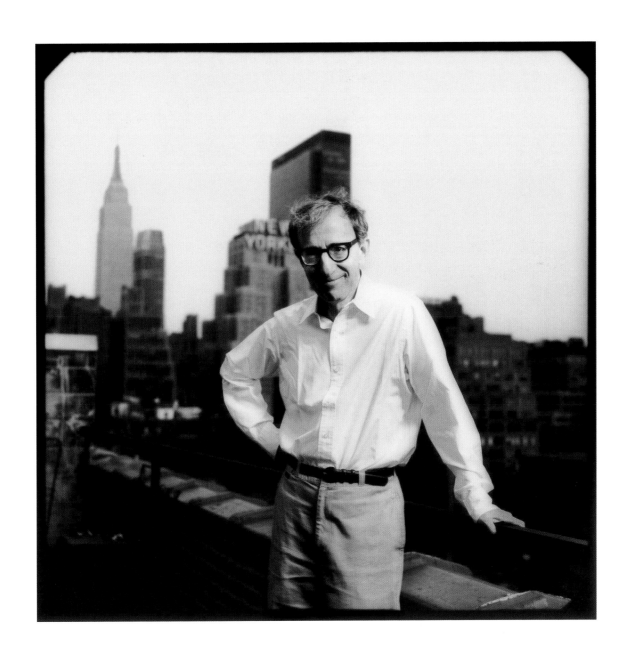

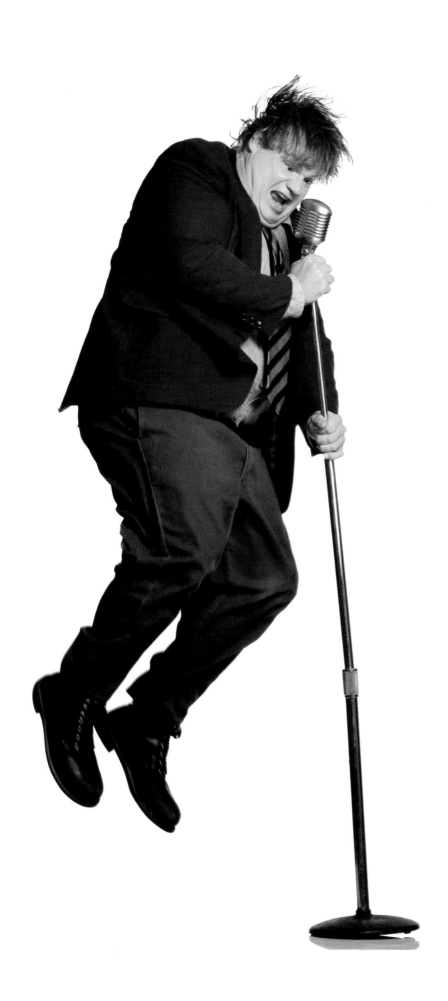

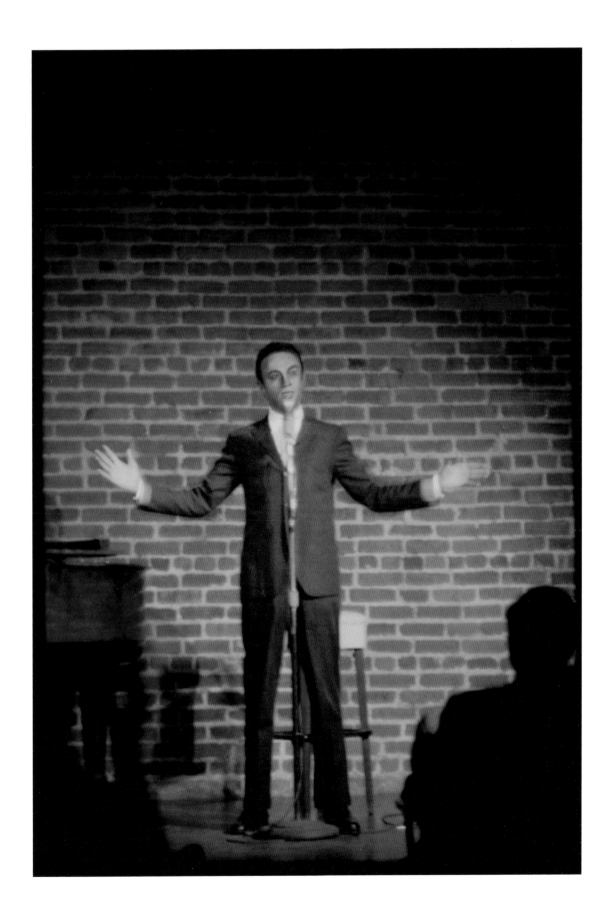

L ooking at the shot of my father by Jim Marshall, then across the page to Timothy White's capture of Chris Farley's energy in a photograph had me thinking. Even though they were entirely two different people, somehow they both seemed to be rocked by an inner frenzy that no immediate self-gratification could ever settle.

—KITTY BRUCE

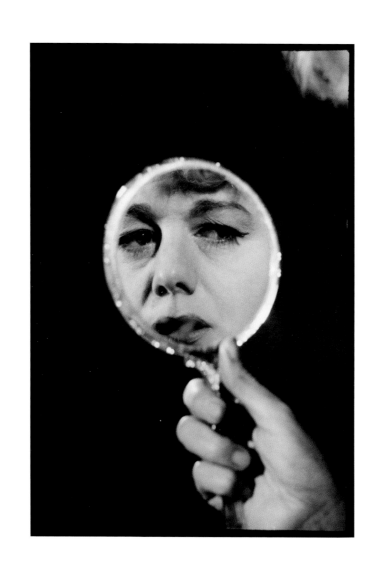

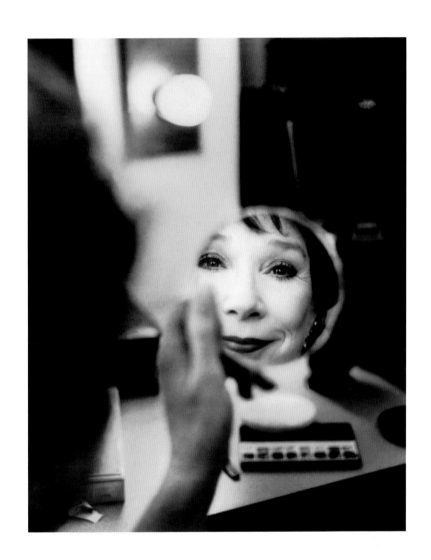

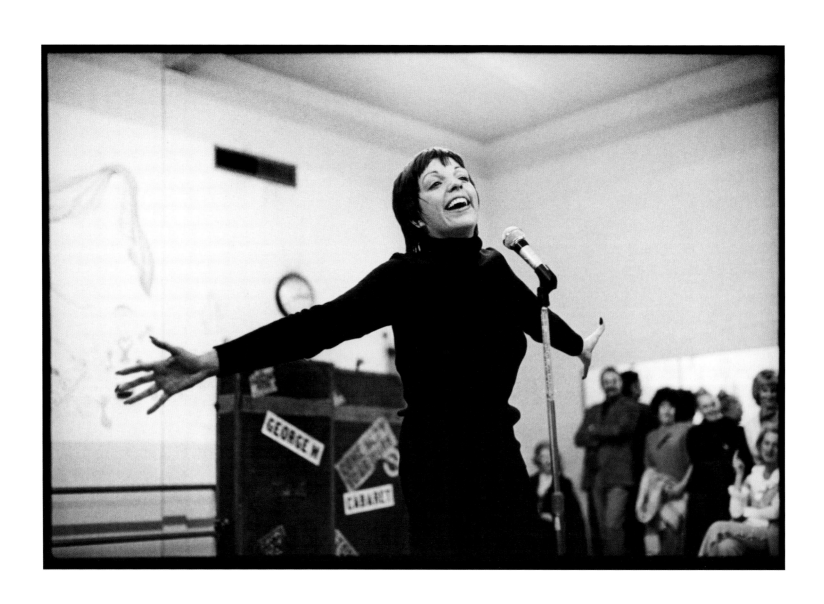

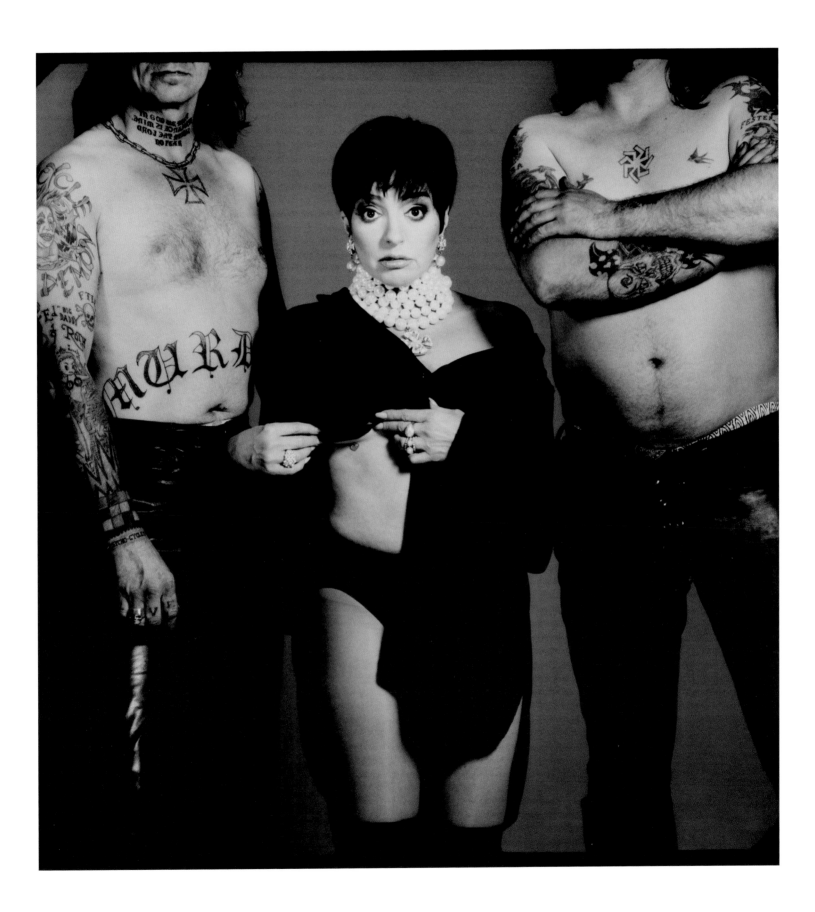

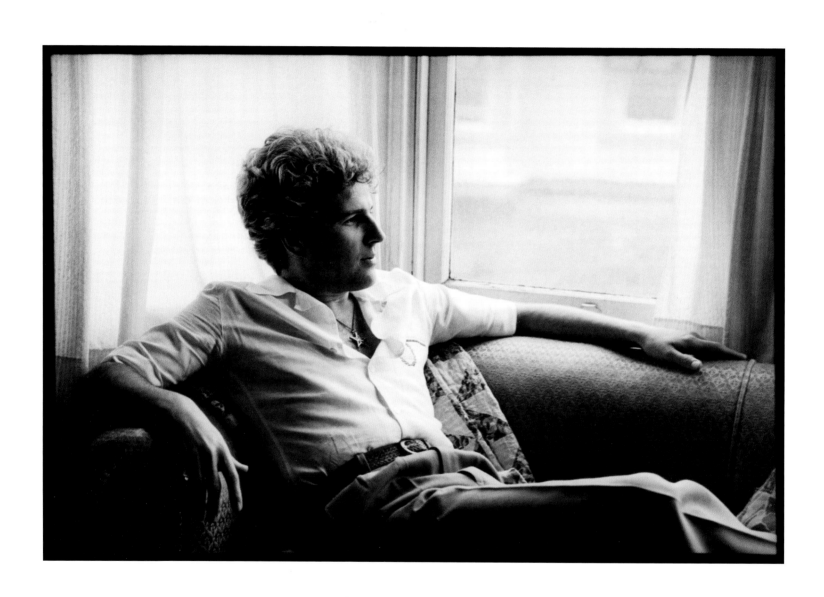

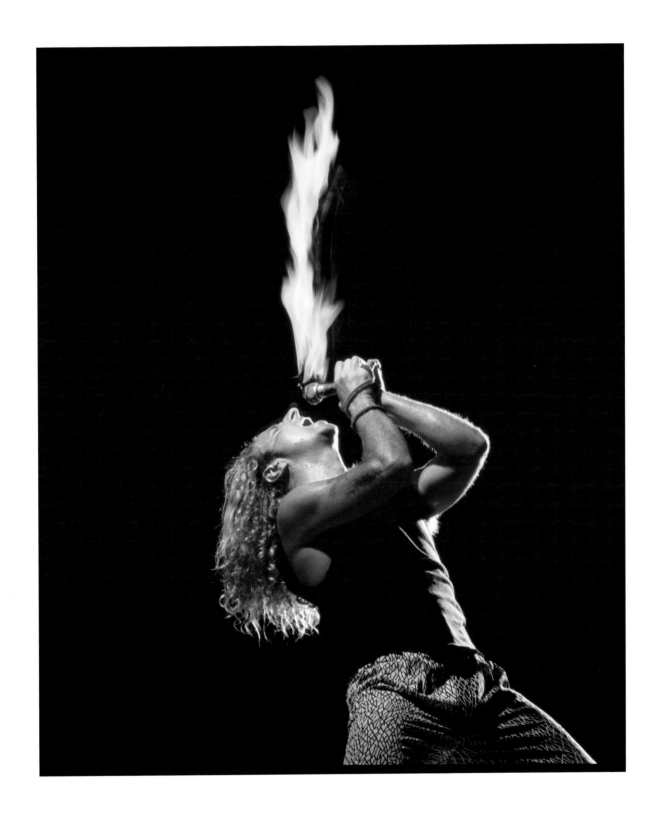

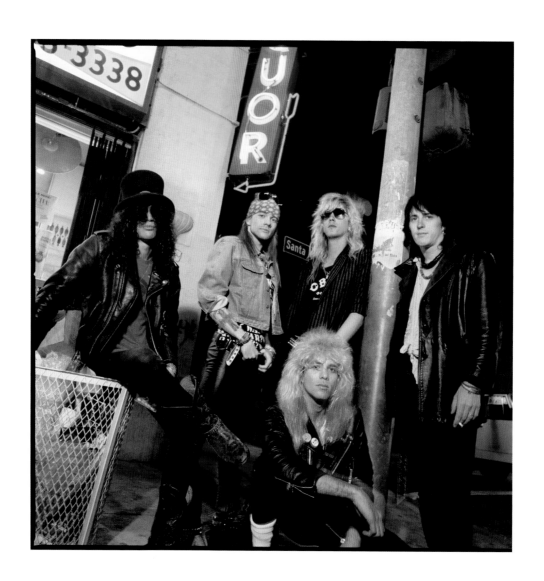

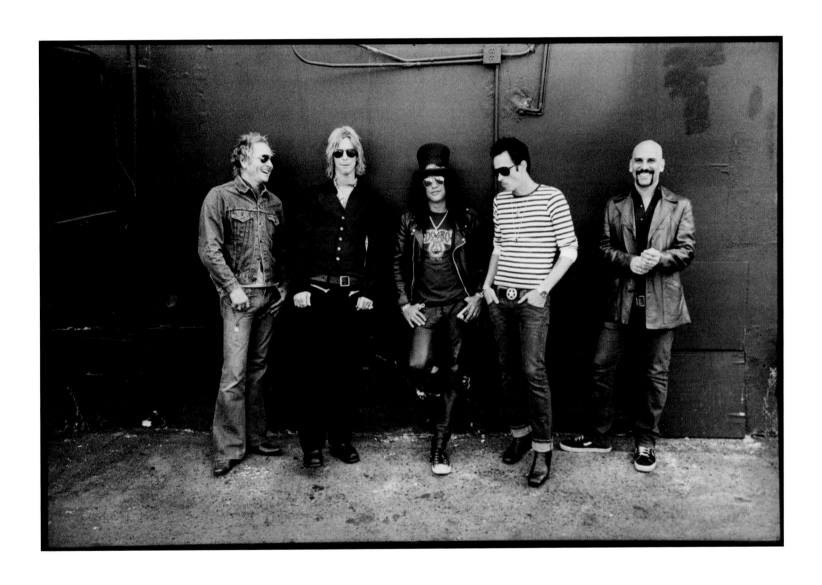

For the first picture [left], the only thing I remember about this shot was it took place on Santa Monica and Cahuenga—why I even remember that I haven't a clue. But this was one of very few group photo shoots we did when the band was starting to take off.

For the second picture, that was the first one I/we ever did with Jim Marshall, even though I've known him forever. Jim has always been a great friend whenever I've run into him and always a good hang in a hotel bar or whatever. I've wanted to do a shoot with him since back in the day, but it never happened until this quick shoot with Velvet Revolver in the millennium. Very casual. Location: parking lot of the Roxy/Rainbow. Sent via Satan.

—SLASH

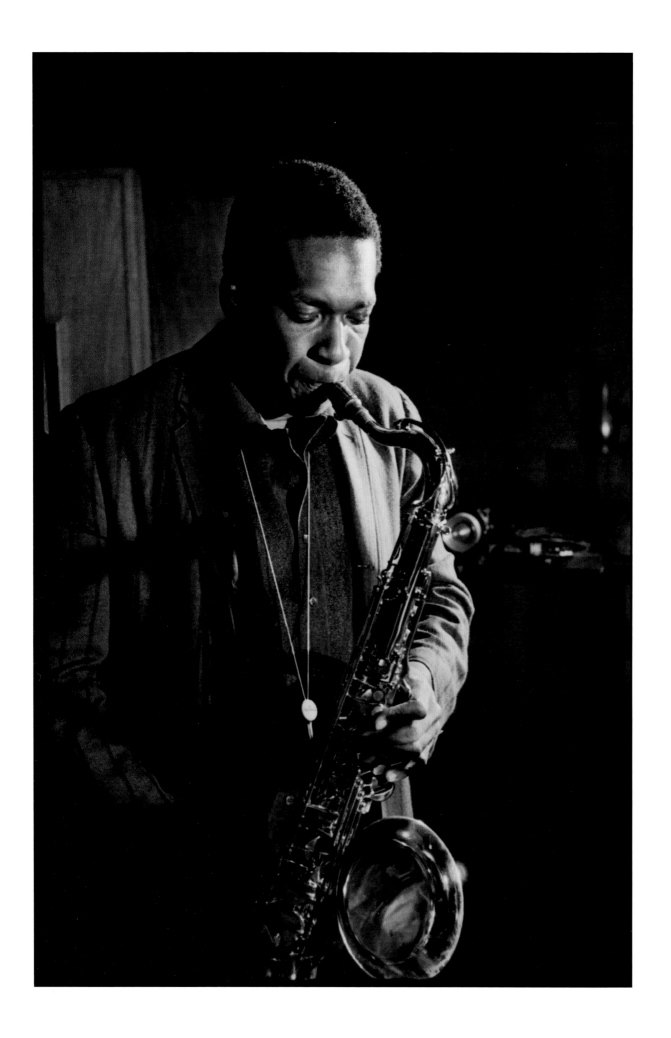

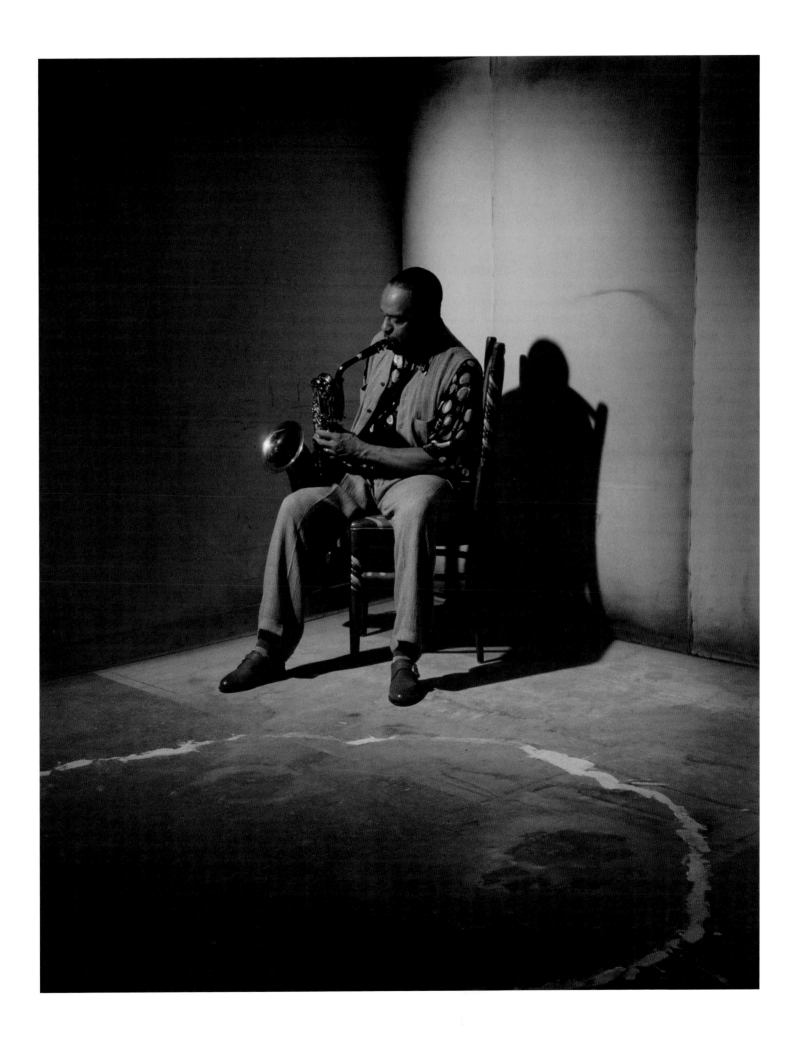

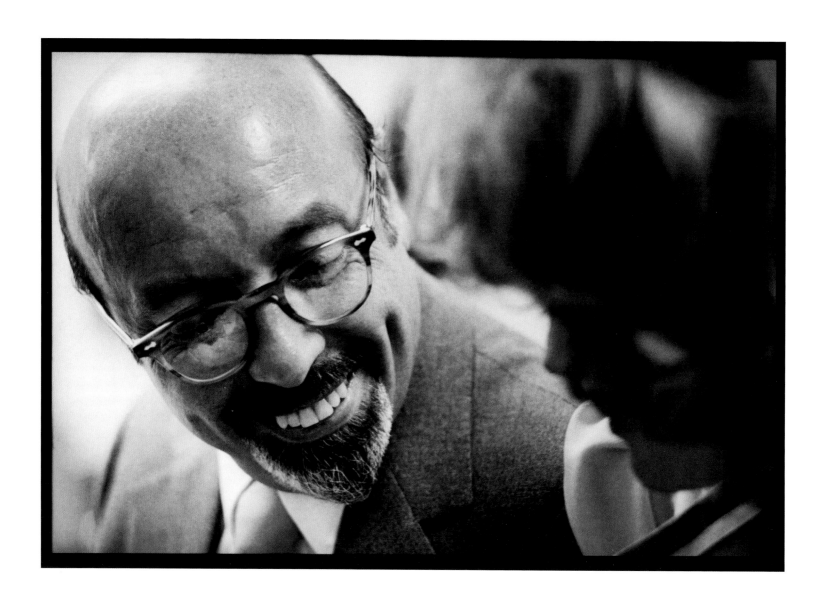

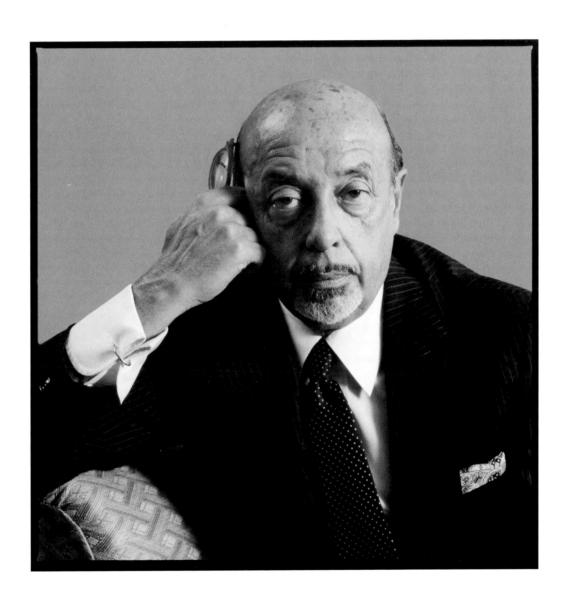

Ahmet Ertegun was the greatest record man who ever lived; his knowledge and involvement spanned seventy years of American popular music, which he brought into all of our lives. He signed some of the greatest pop, rhythm and blues, and rock 'n' roll artists of all time. He looked like a combination of an oriental pasha and the Wizard of Oz. He was always turned out in a precisely trimmed goatee, never a wrinkle in his clothes. He could outlast anyone at any bar or any other place you could name, and he had very little interest in sleep. He dazzled. His was a lifetime of laughter, grace, love, and learning. What luck I had to be there with him.

—JANN S. WENNER

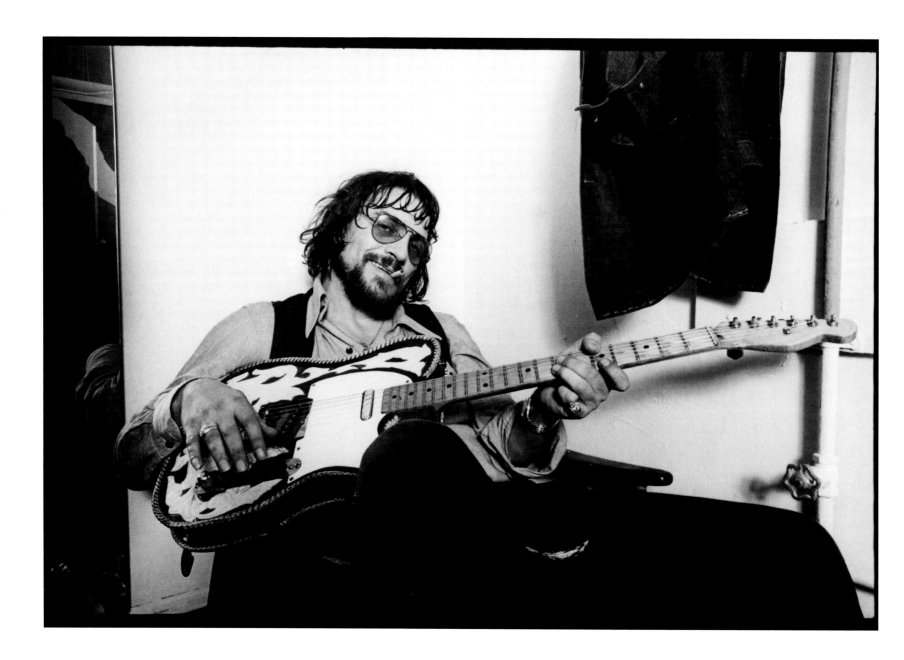

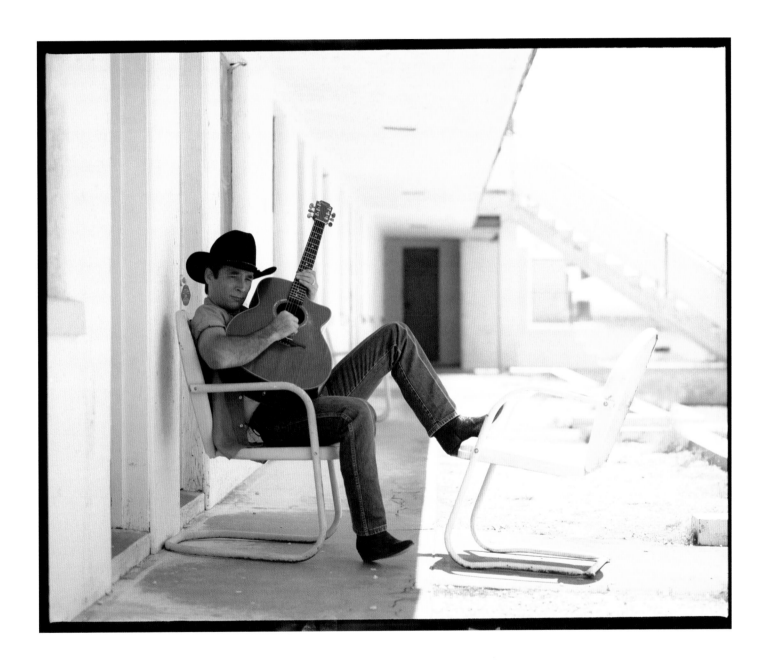

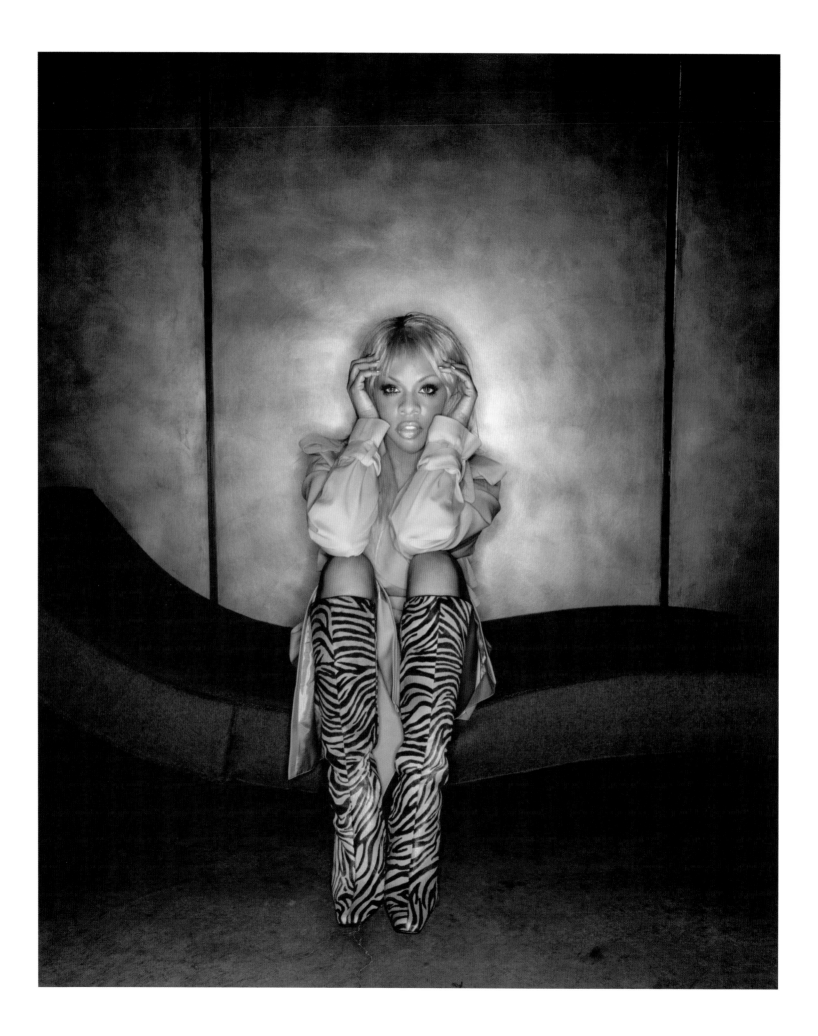

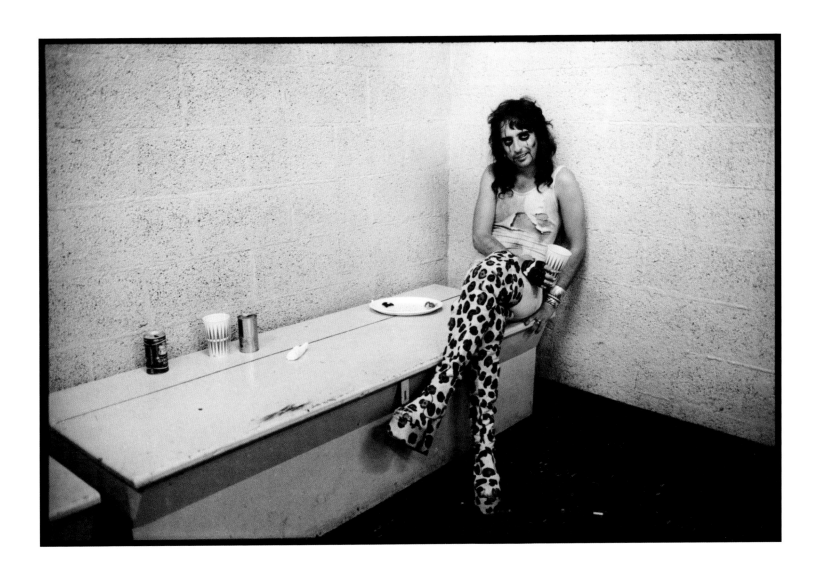

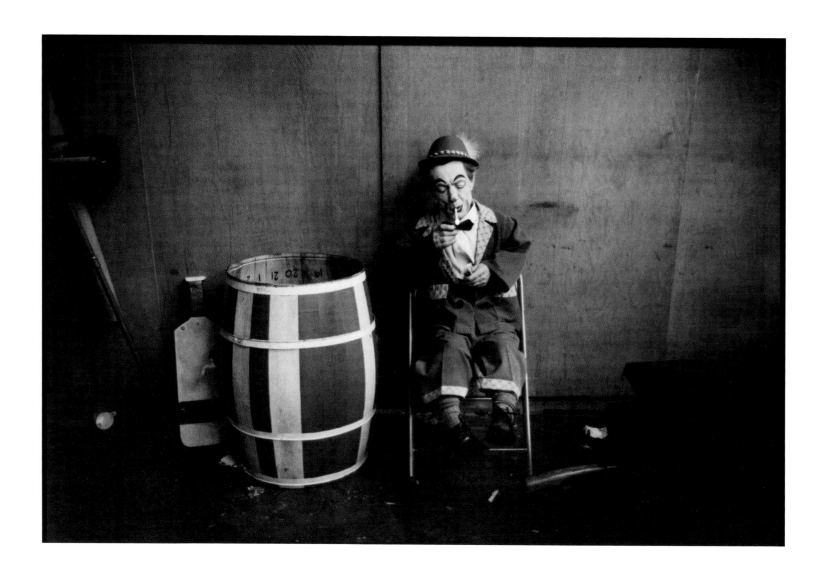

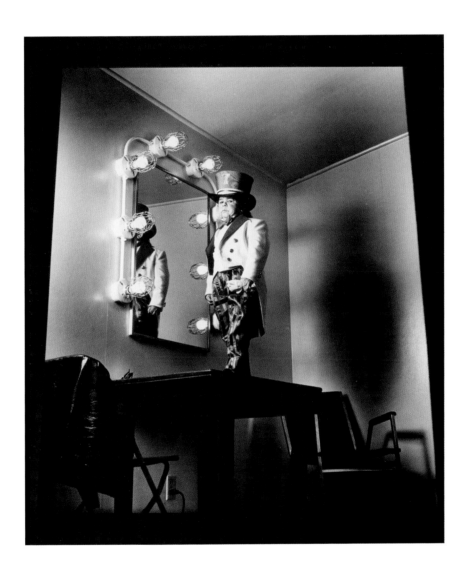

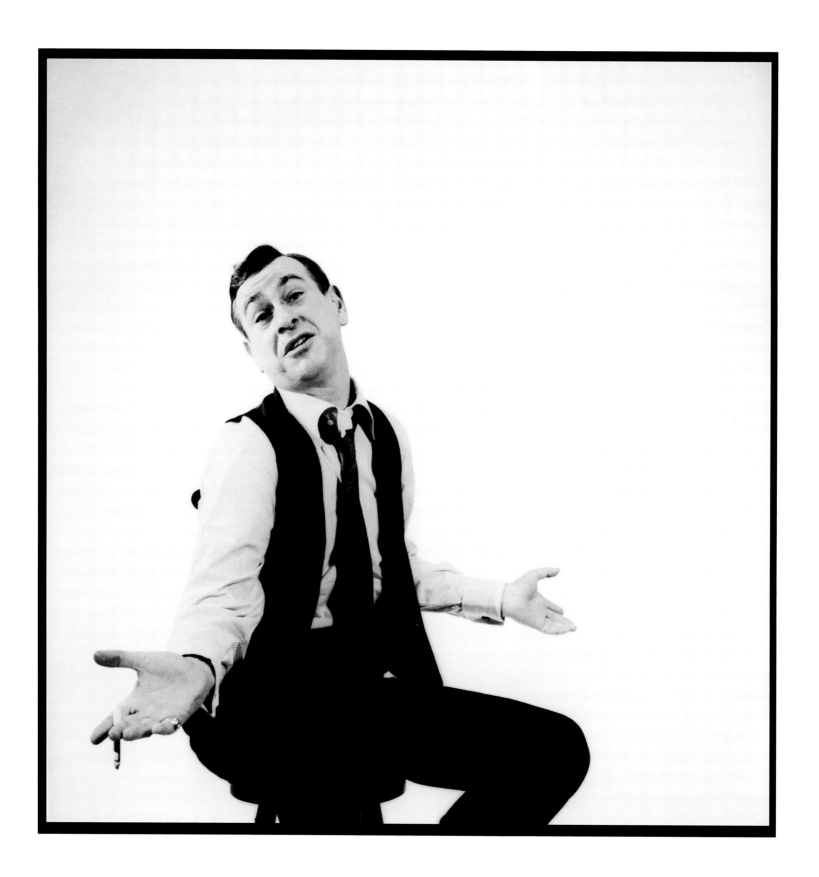

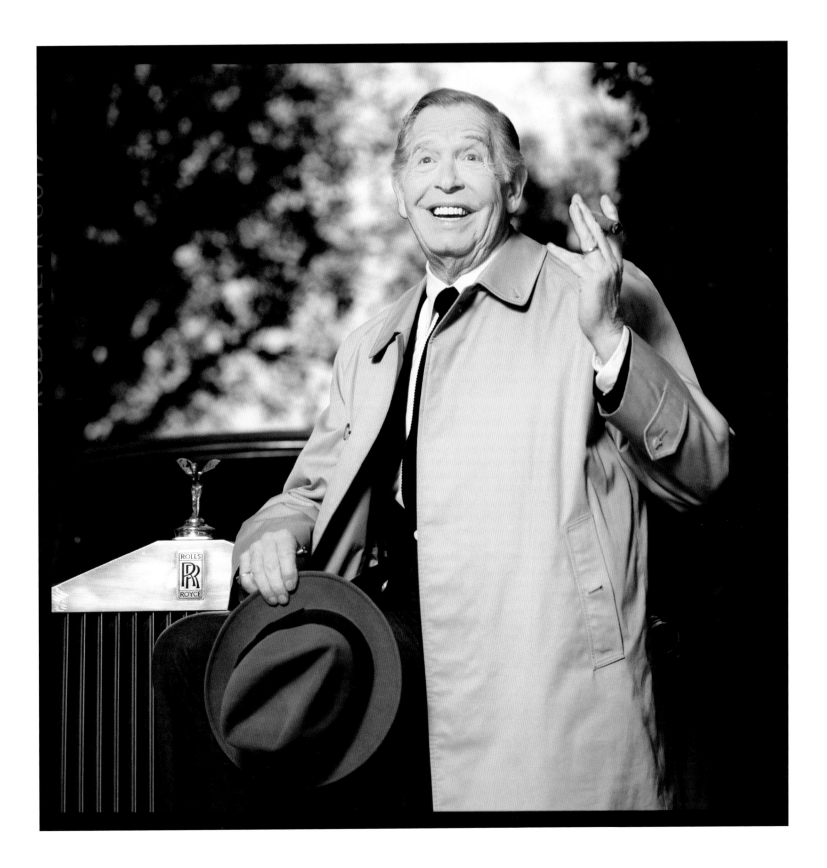

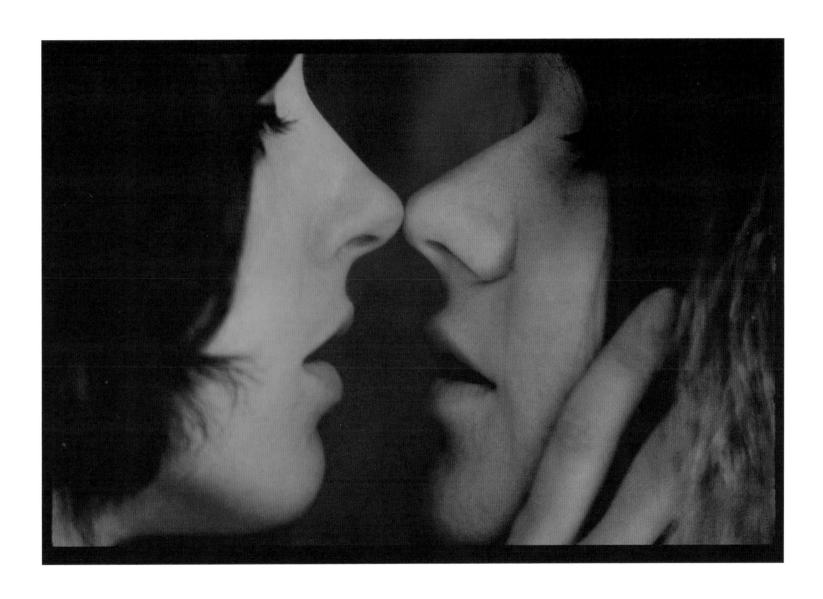

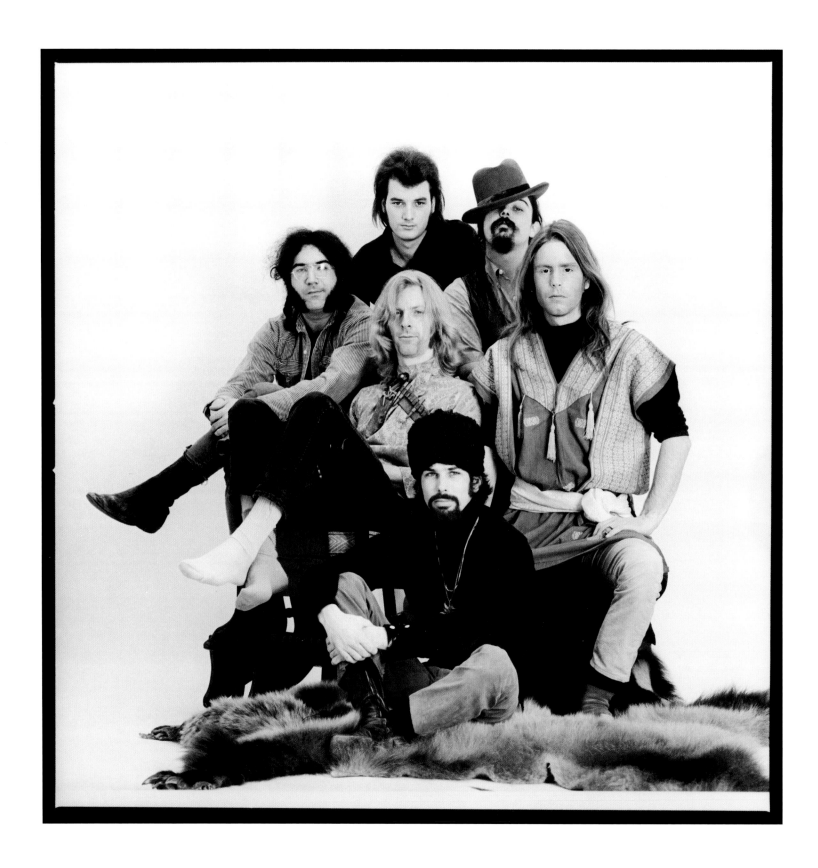

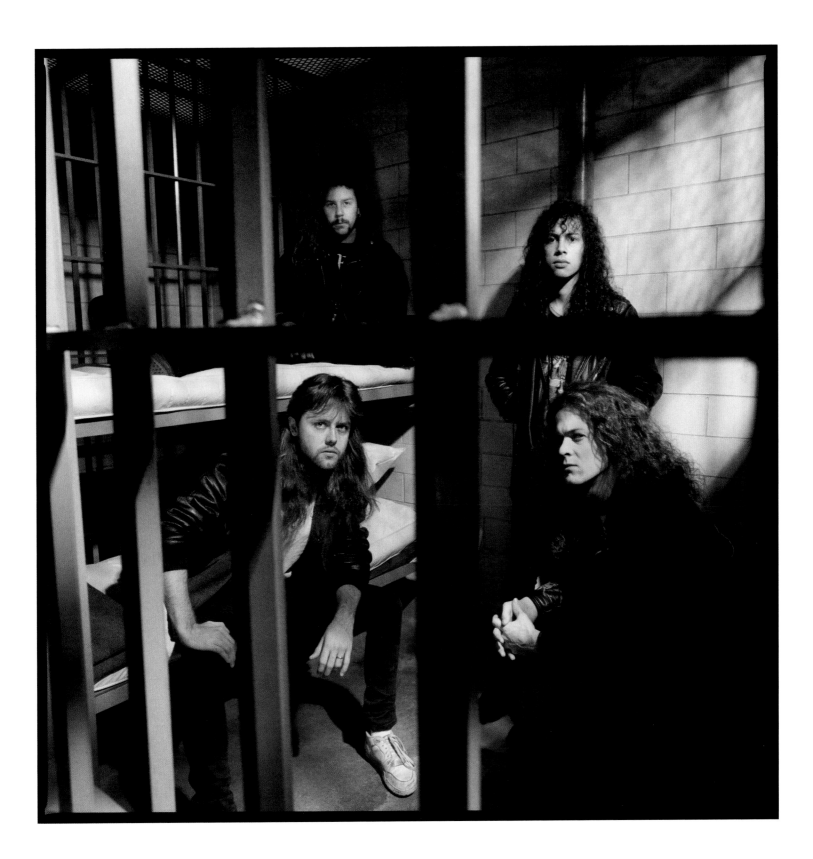

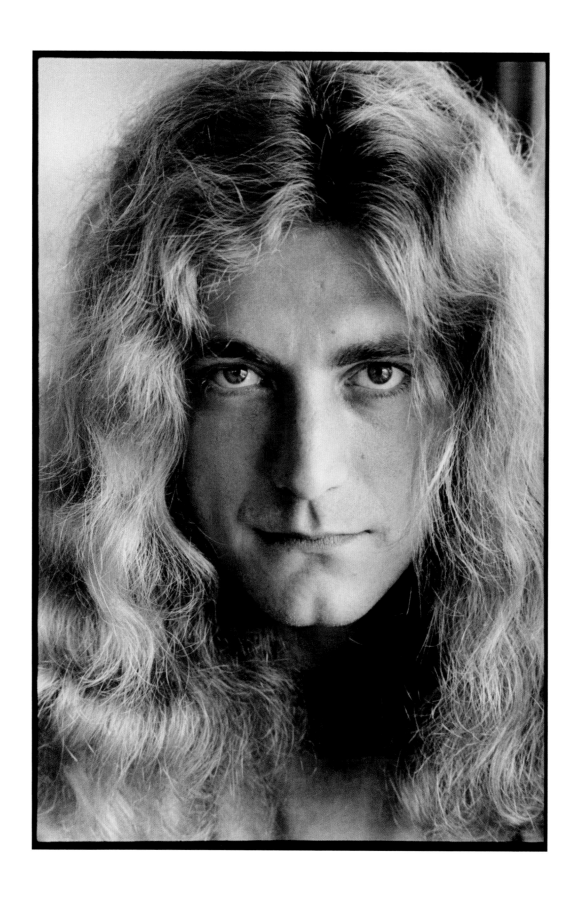

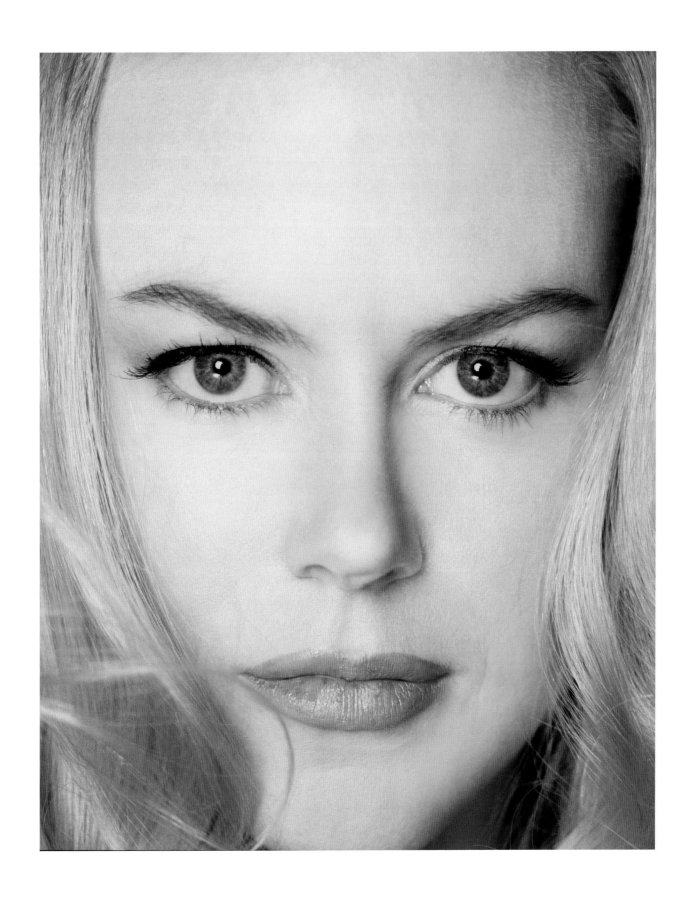

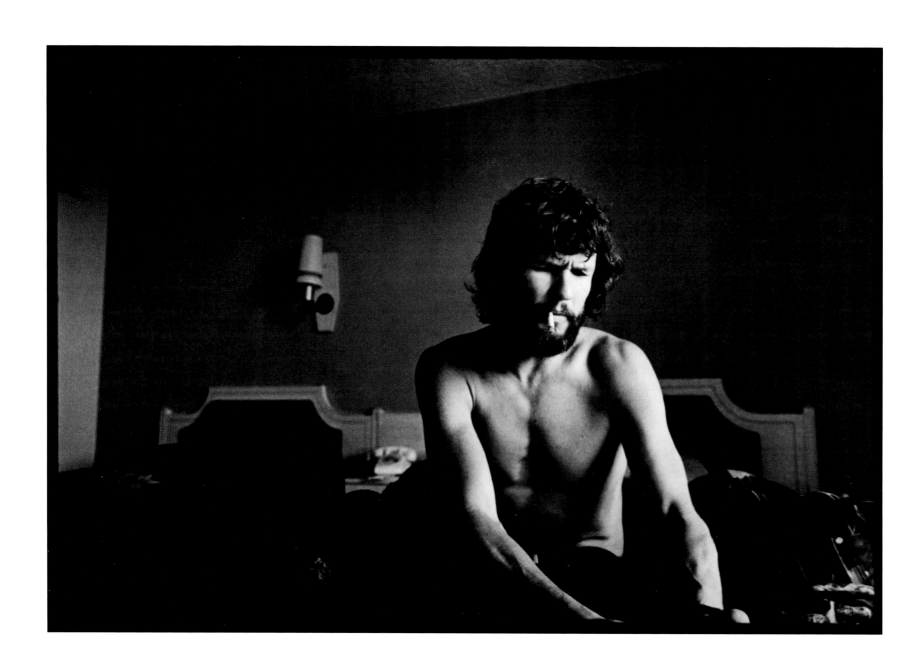

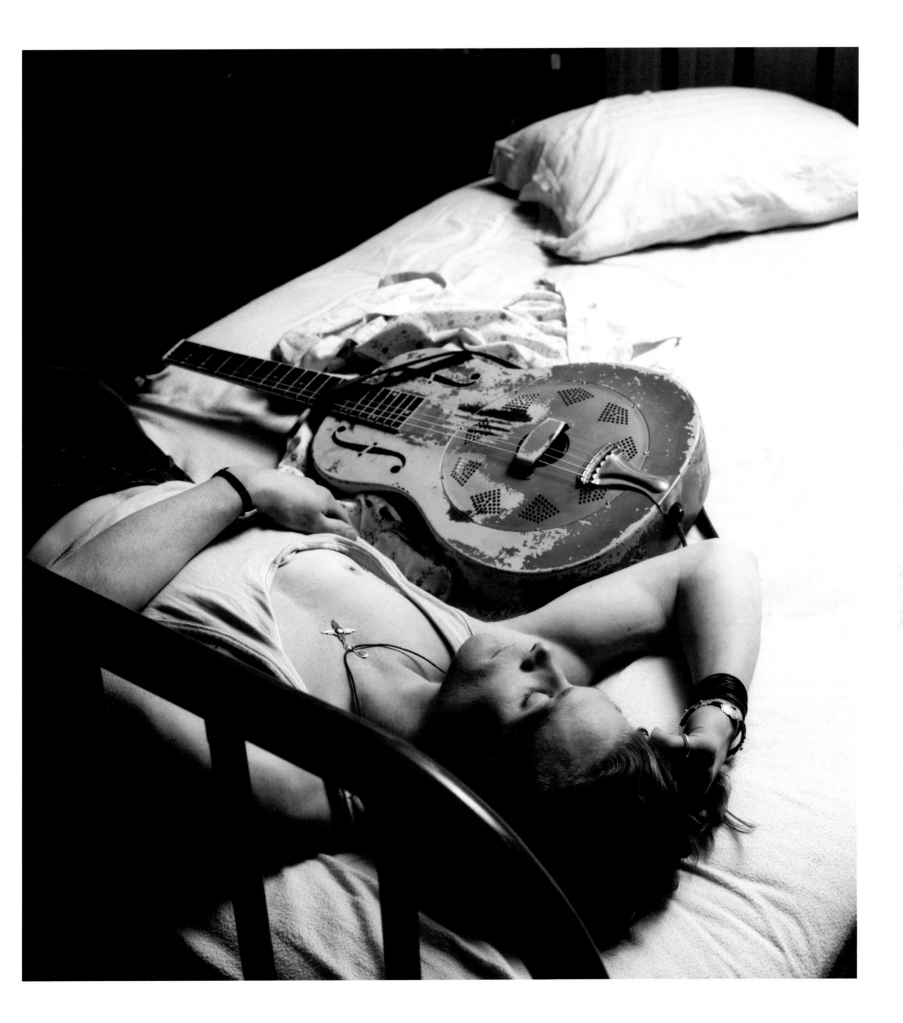

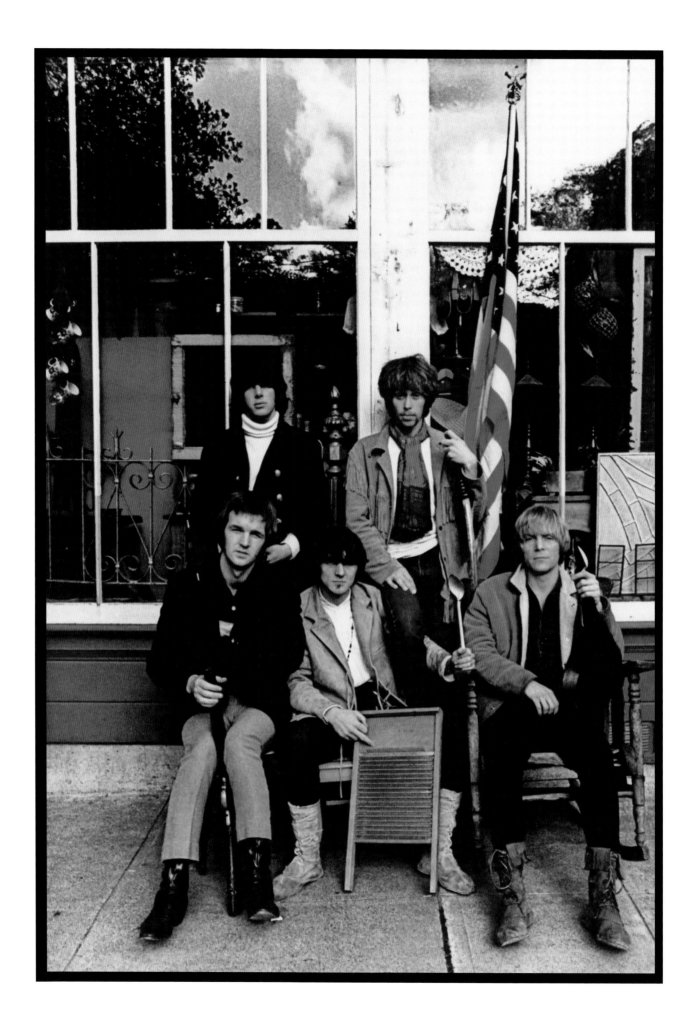

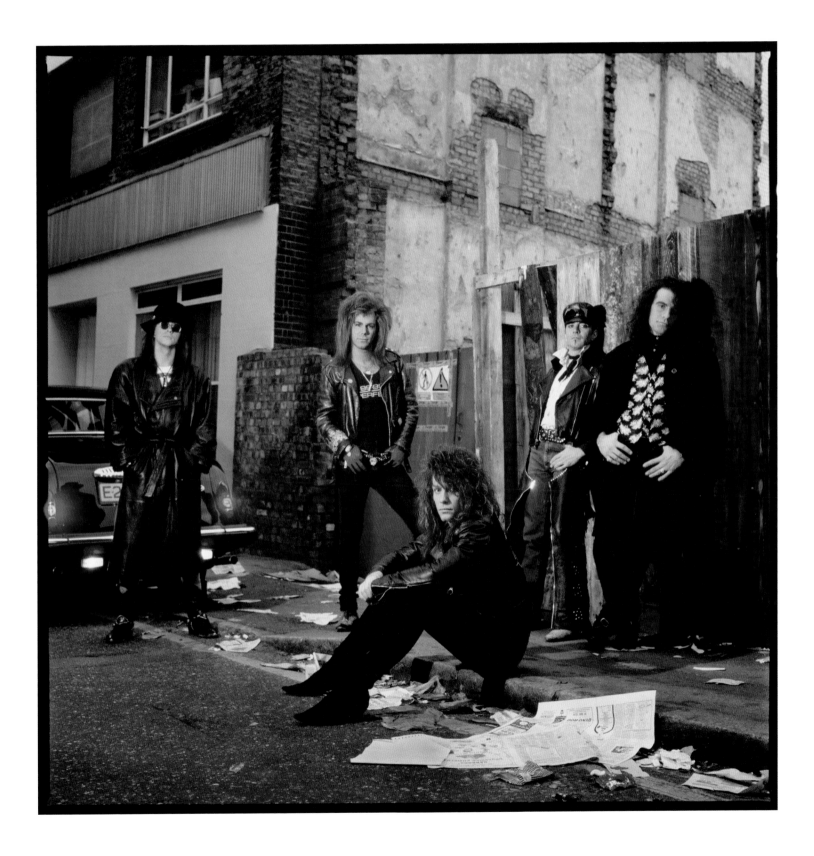

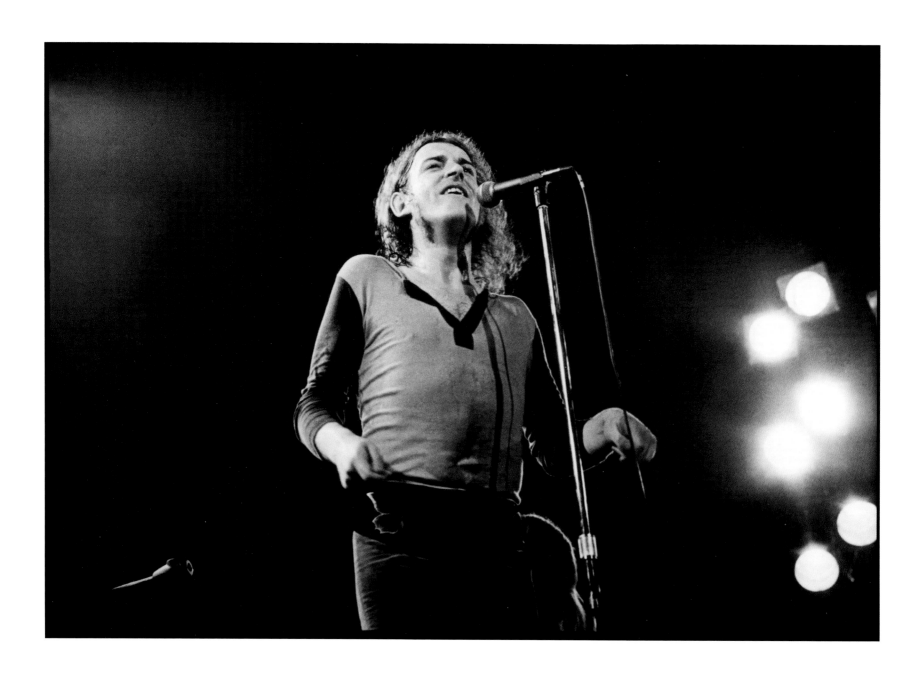

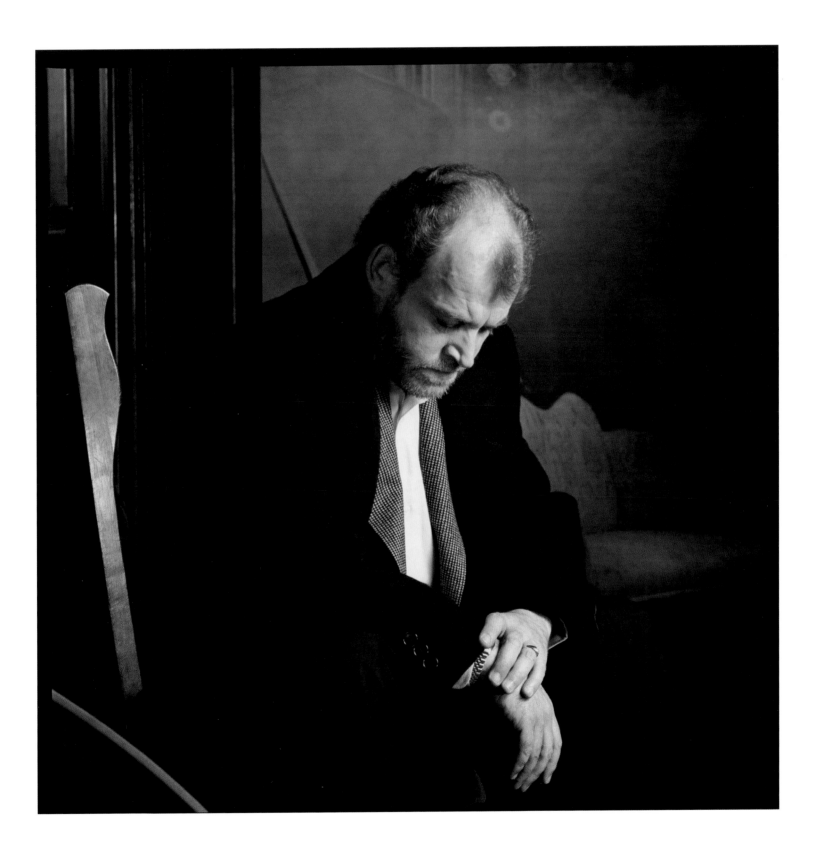

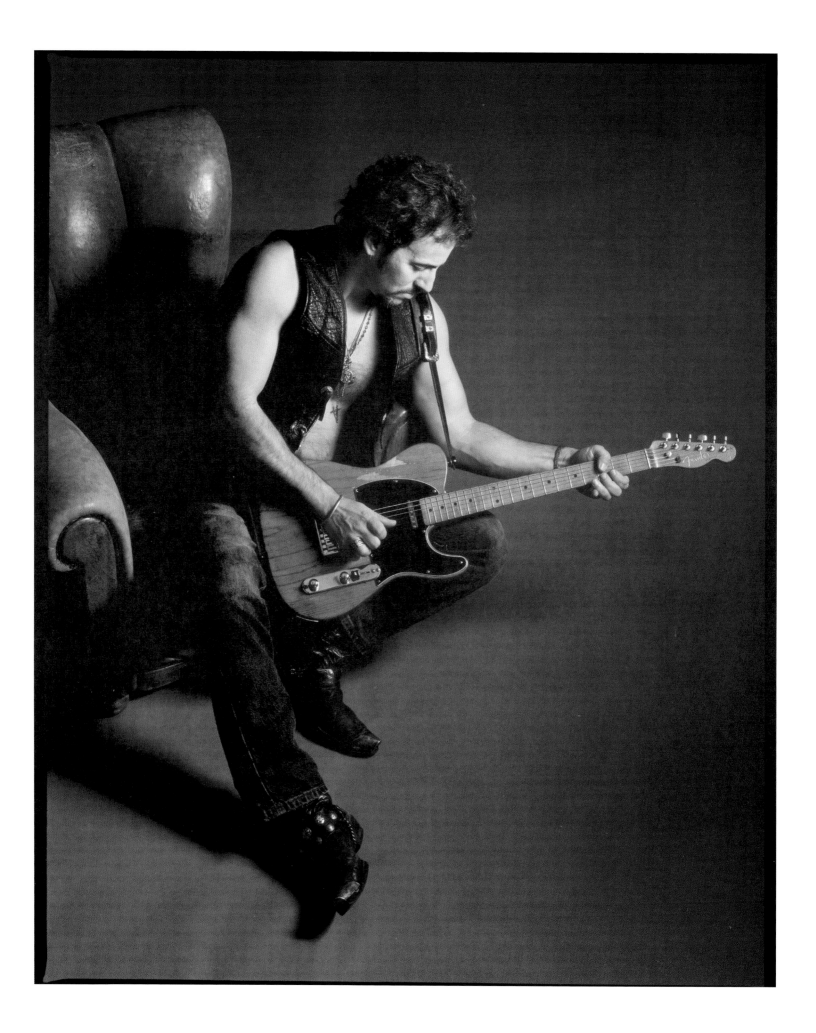

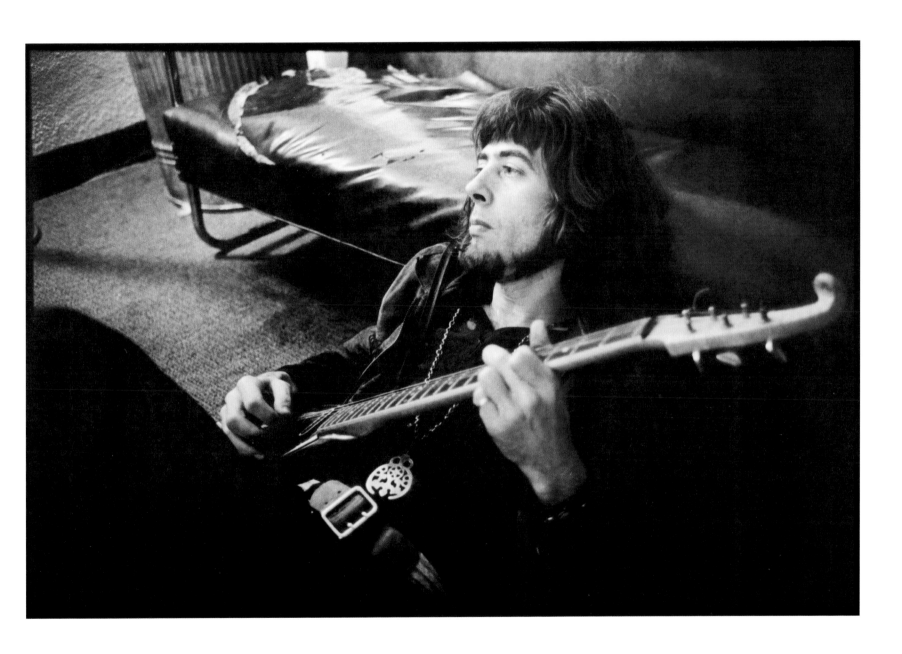

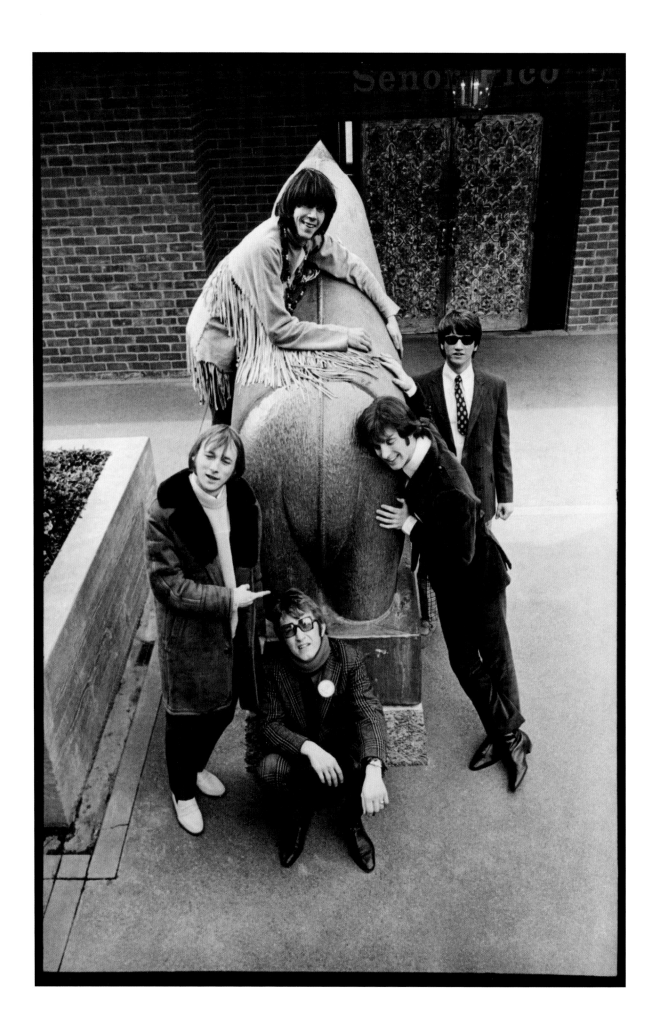

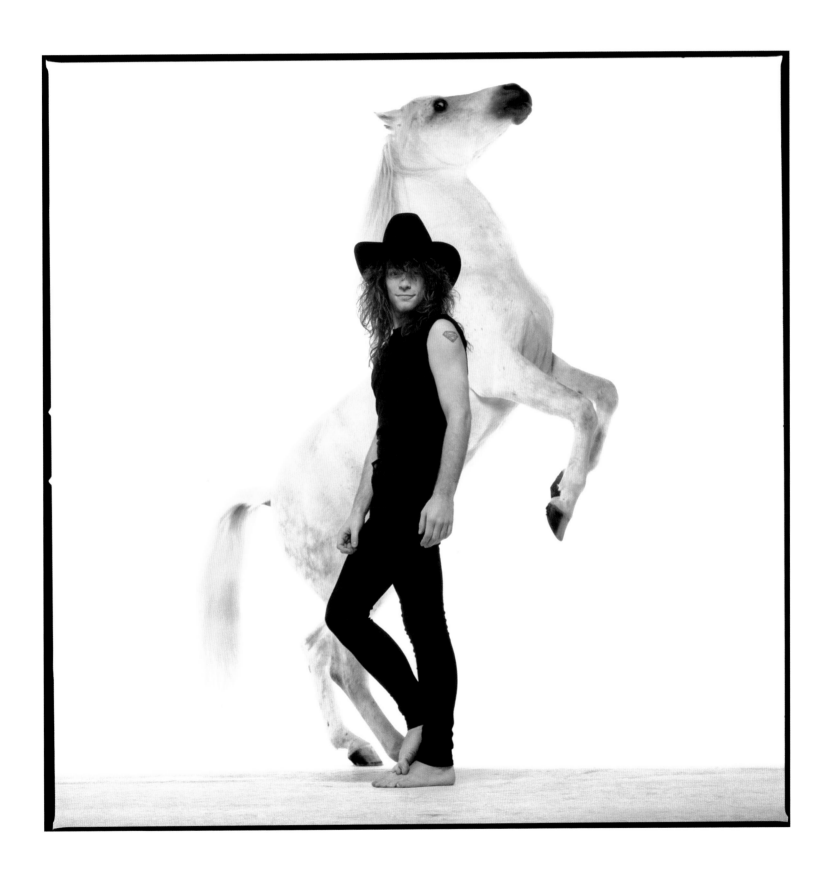

Some photographers take pictures, others mark moments in time. Tim is associated with the latter. His shot of me and my friend the horse was taken in London for the cover of *Rolling Stone*. It was magical. The horse was as real and was as close to me as he appears to be. I stood barefoot, trying to stand as tall as I could while trying to make myself as small as possible. That is why I have one foot on the tip of the other. Had that horse been spooked or fallen off his mark, I'd have been a goner—in a blaze of glory.

—JON BON JOVI

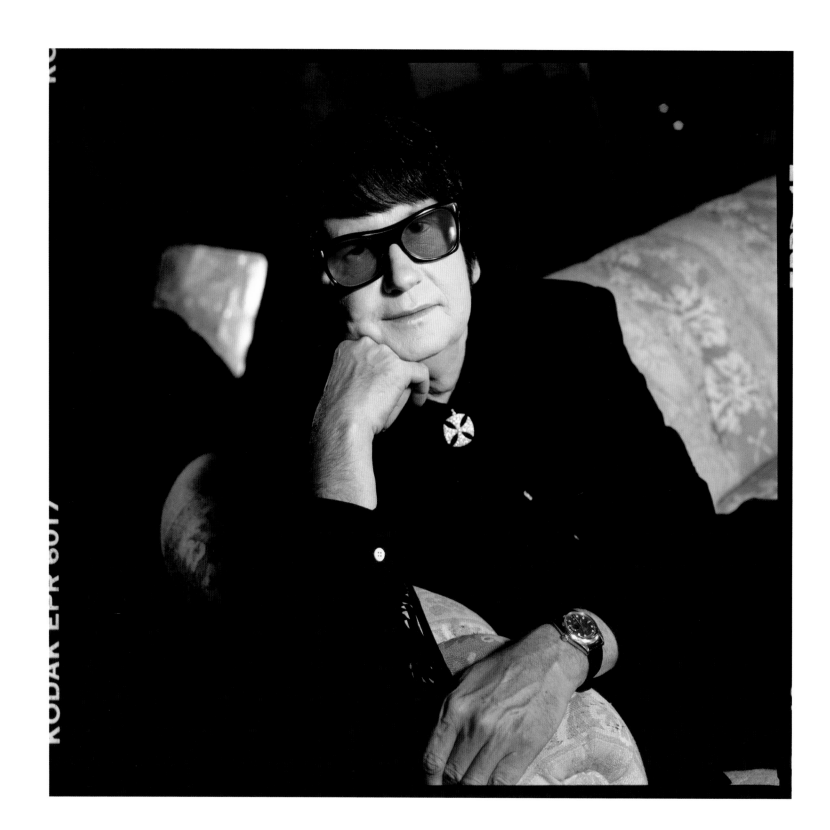

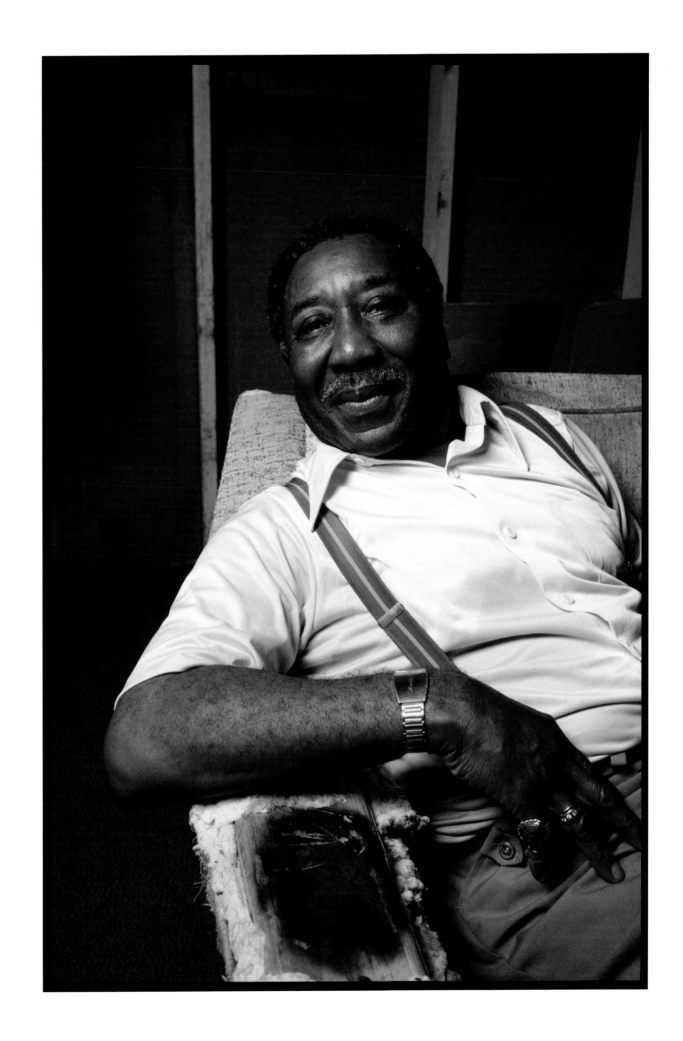

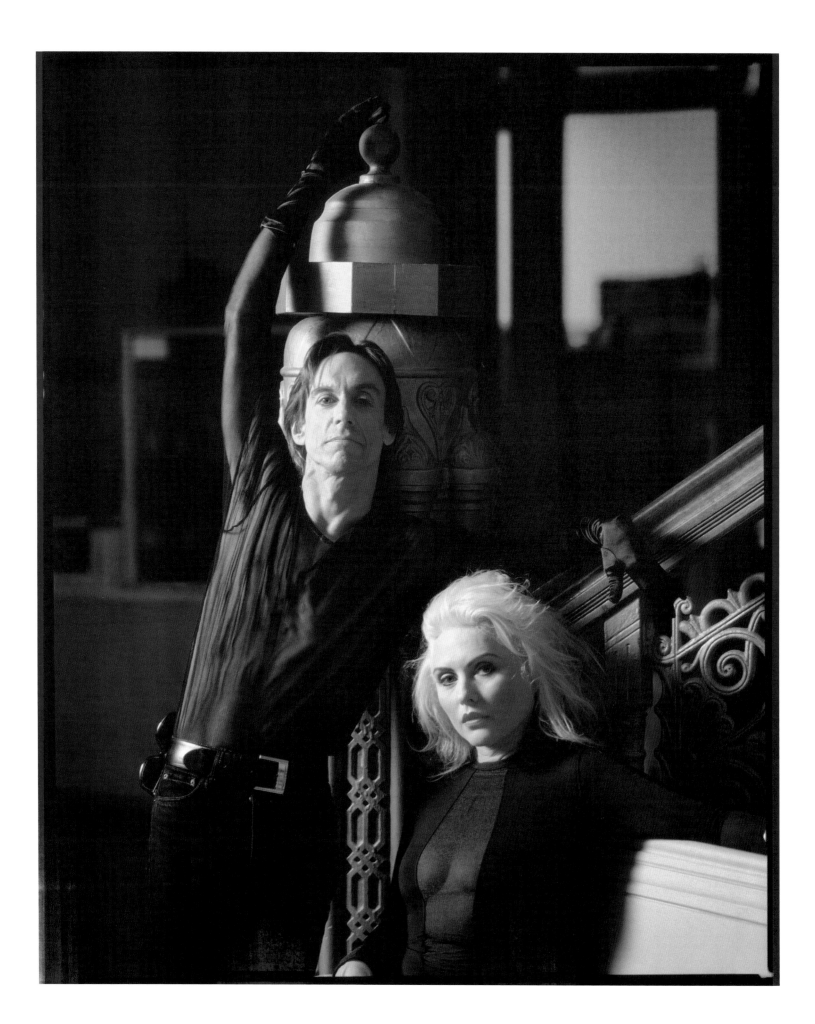

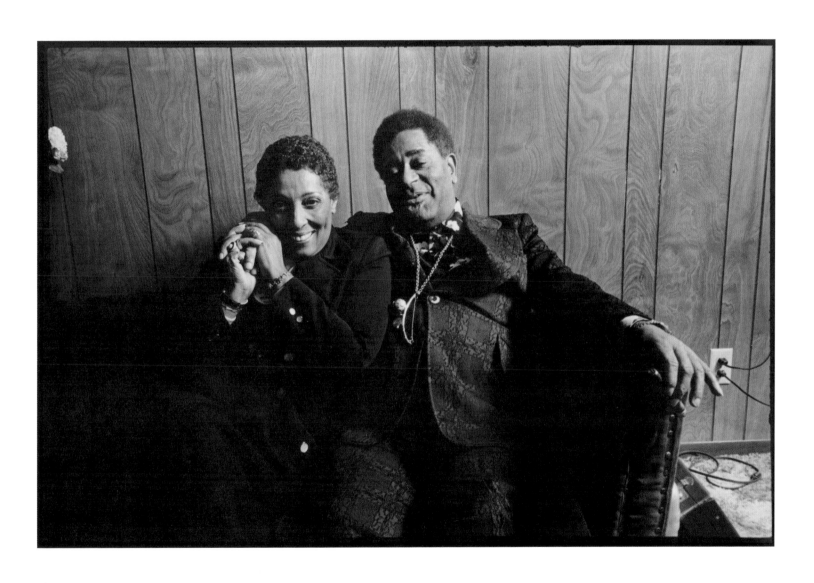

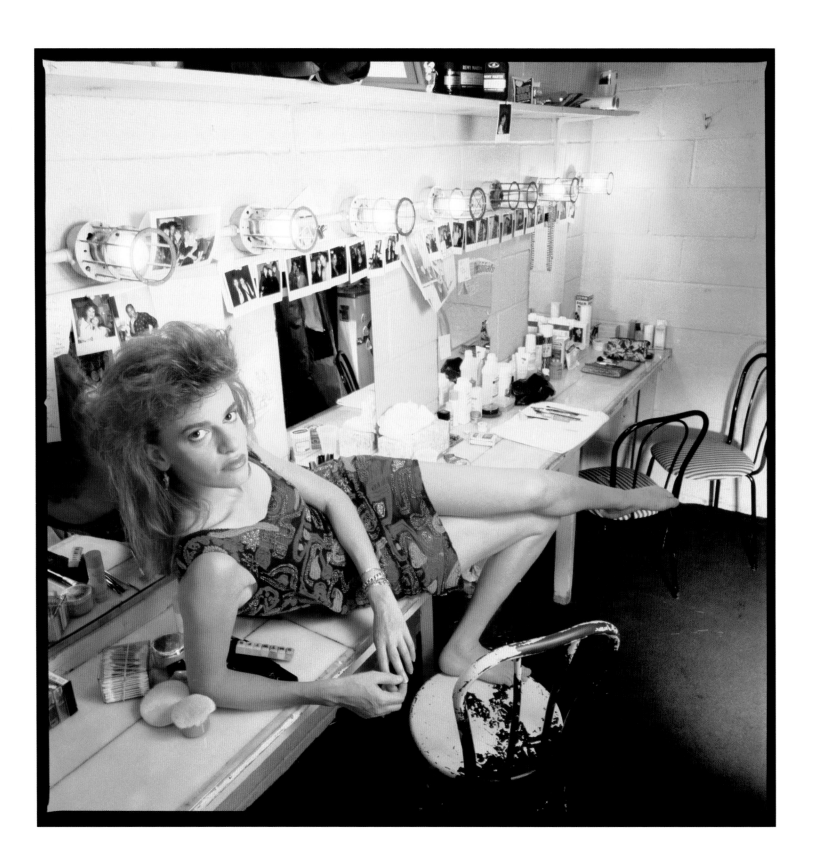

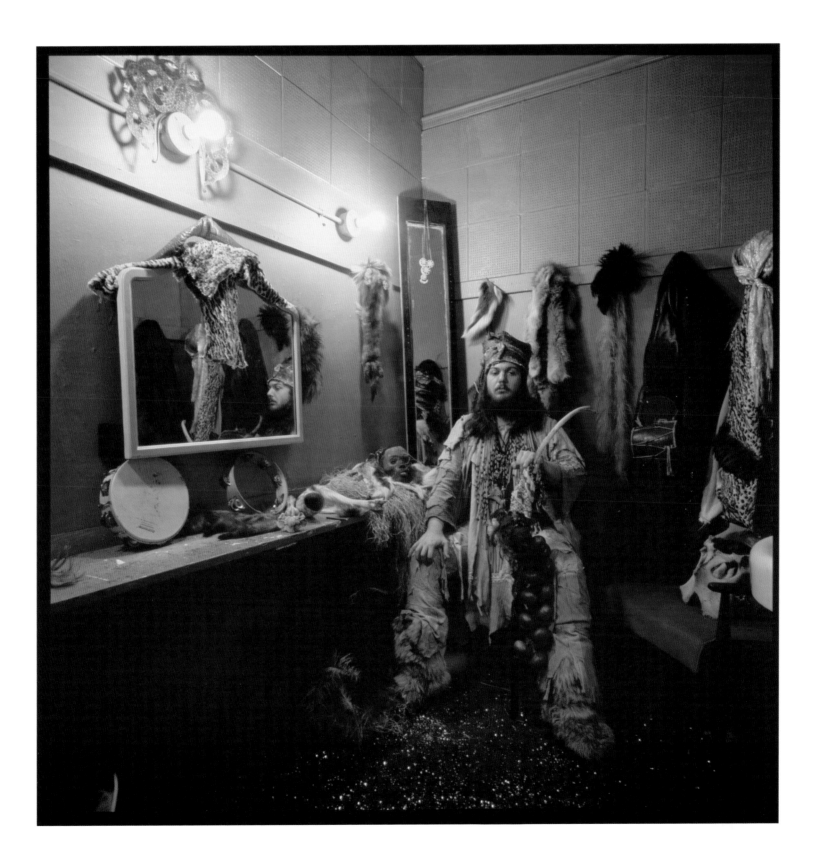

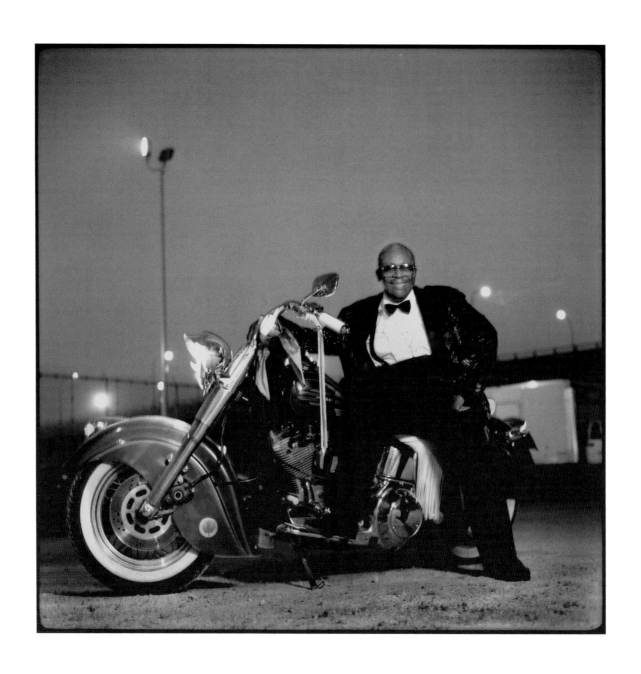

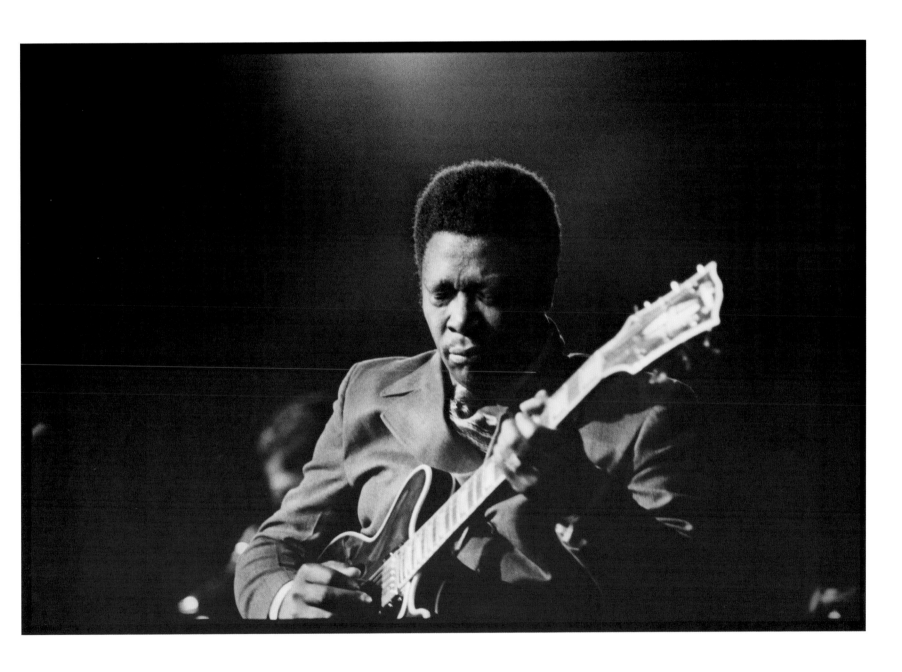

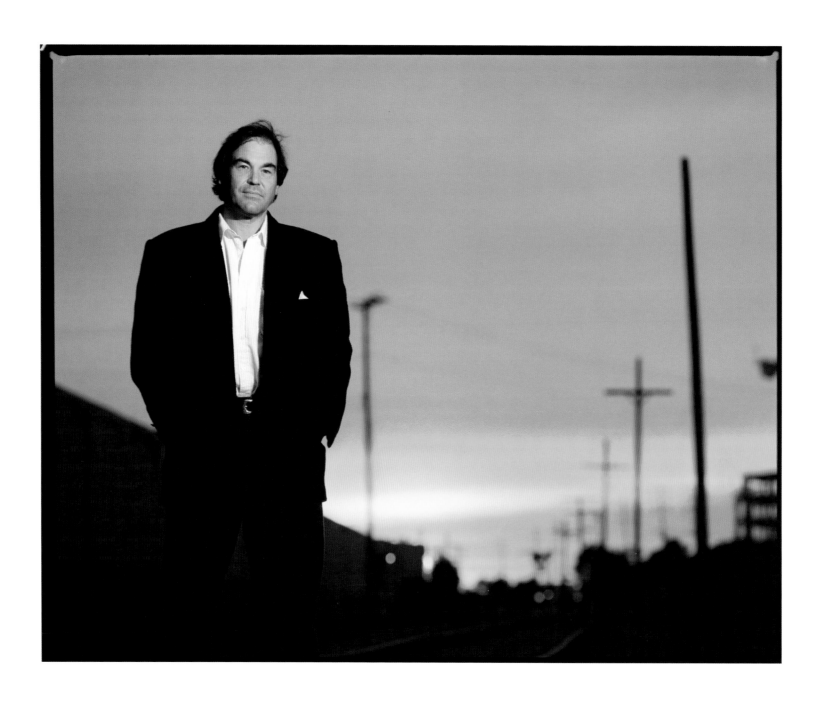

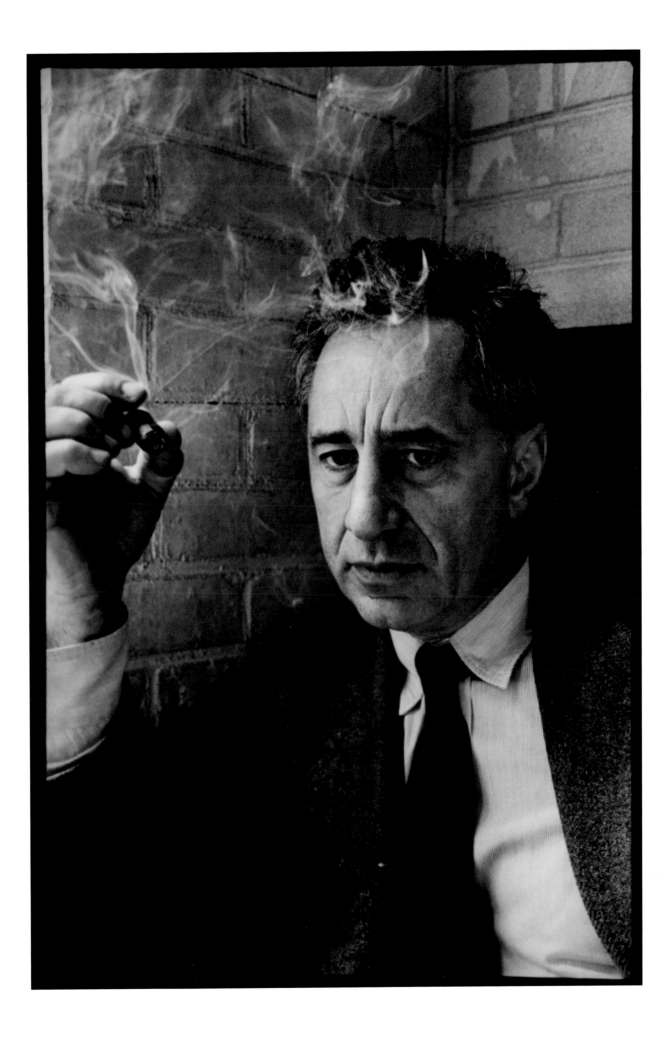

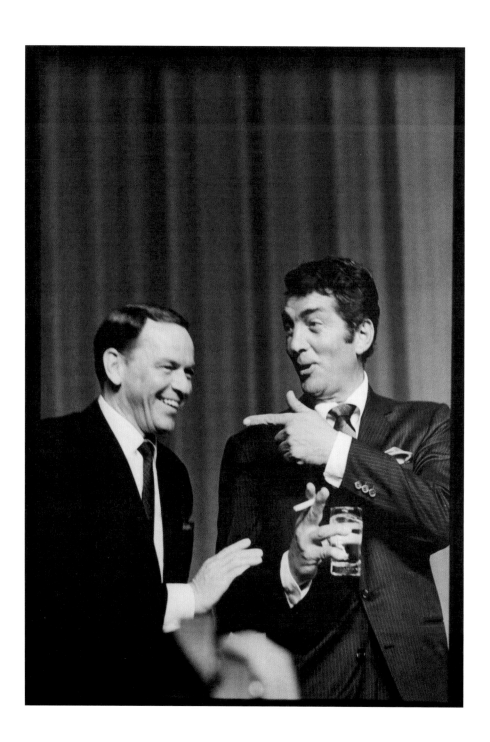

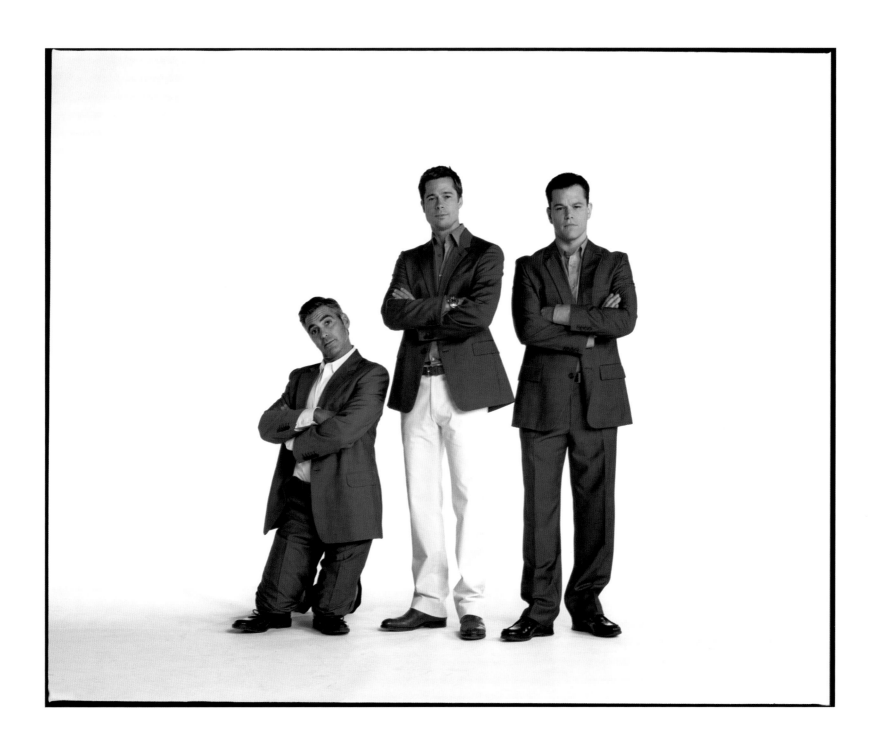

When viewing these images, I'm reminded that all things must pass.

—BRAD PITT

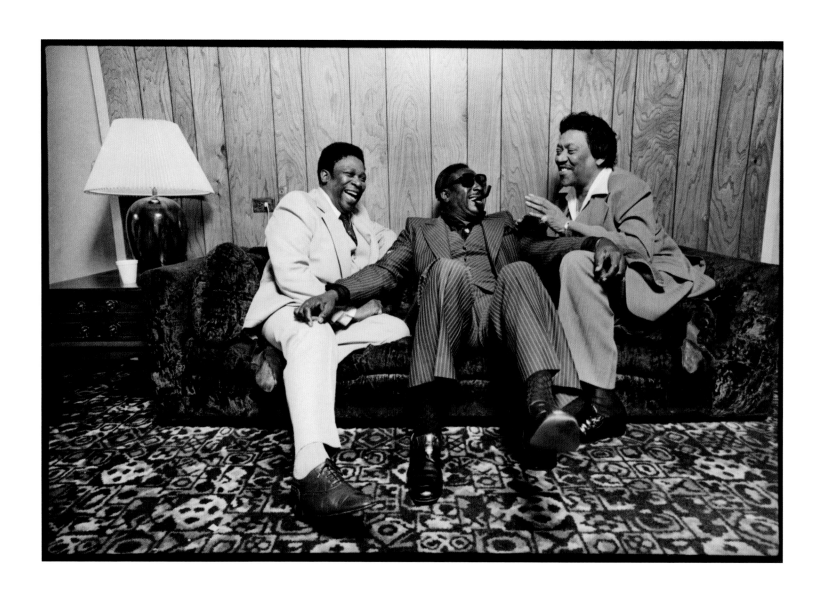

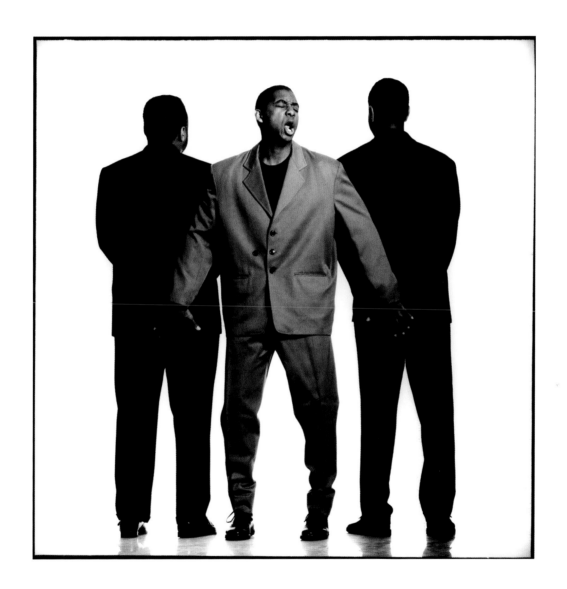

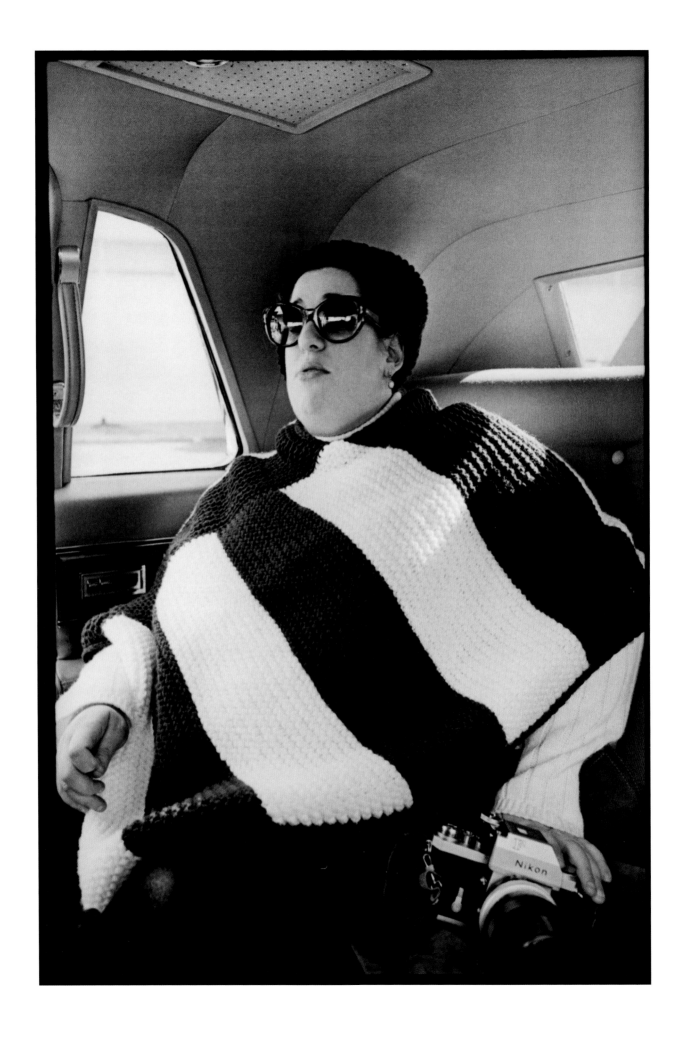

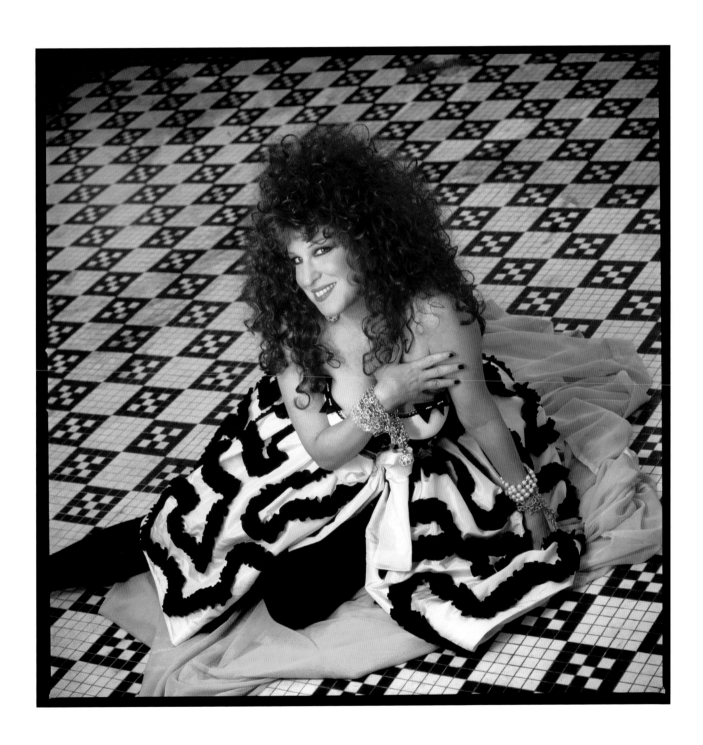

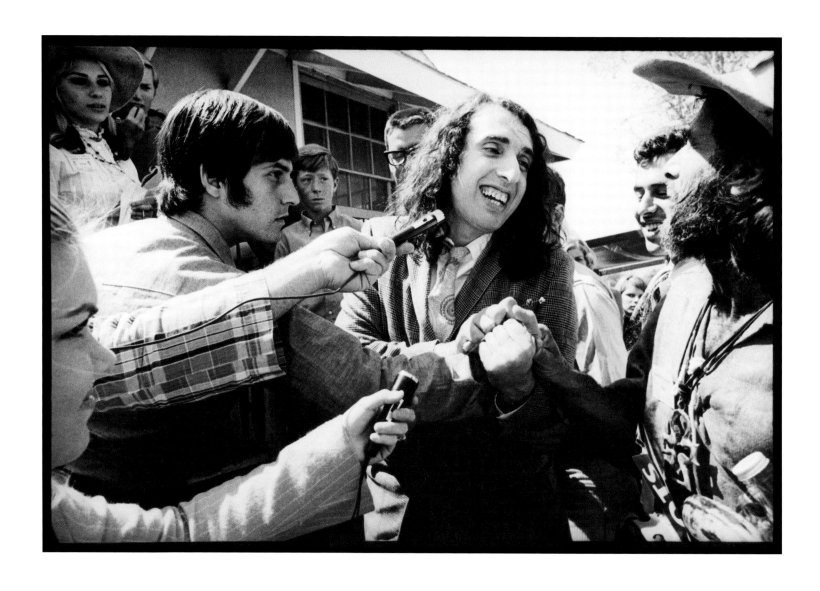

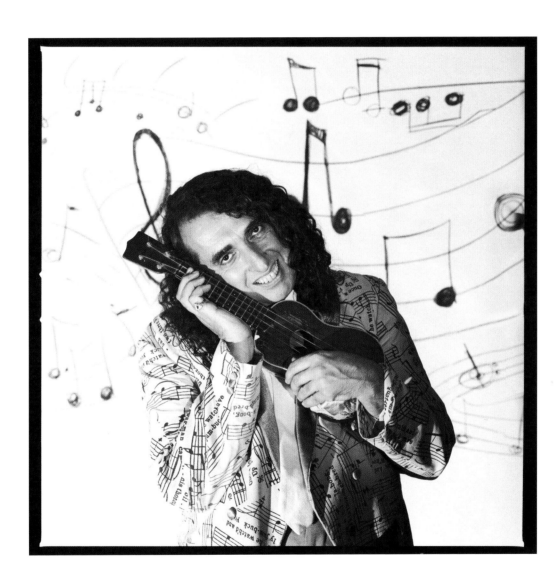

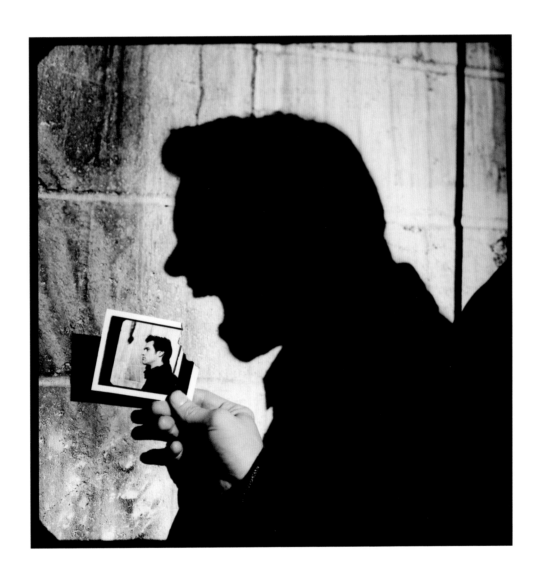

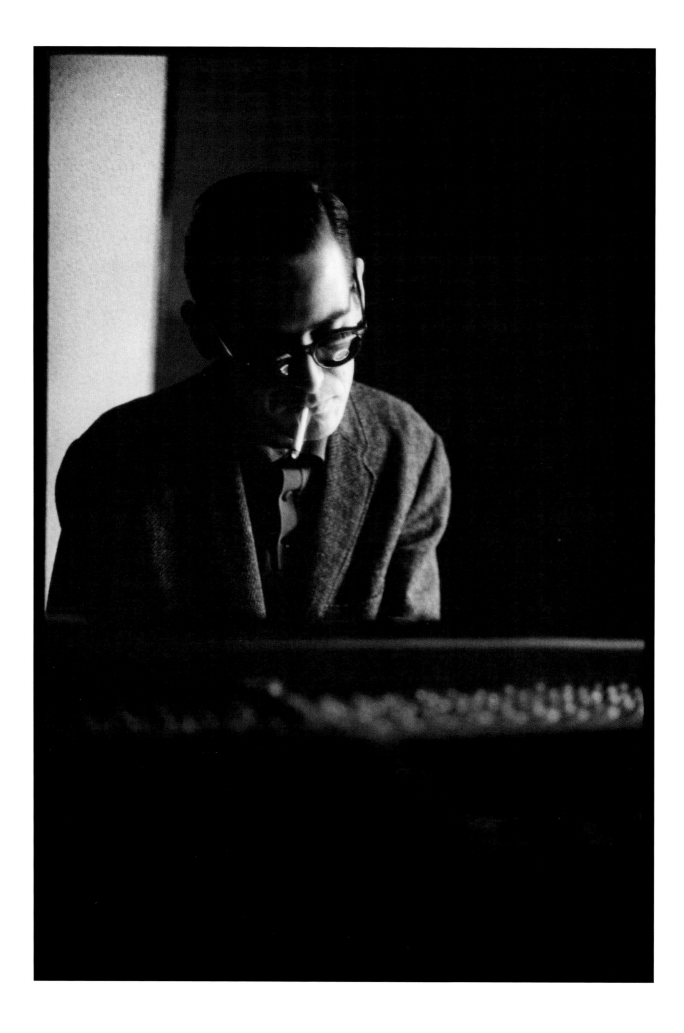

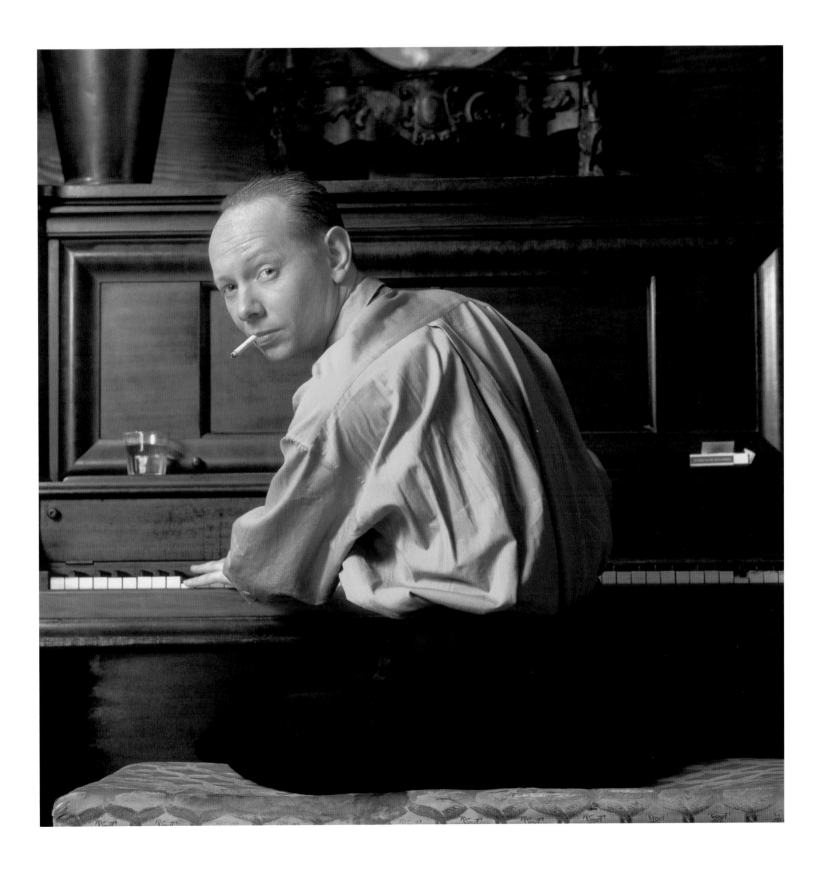

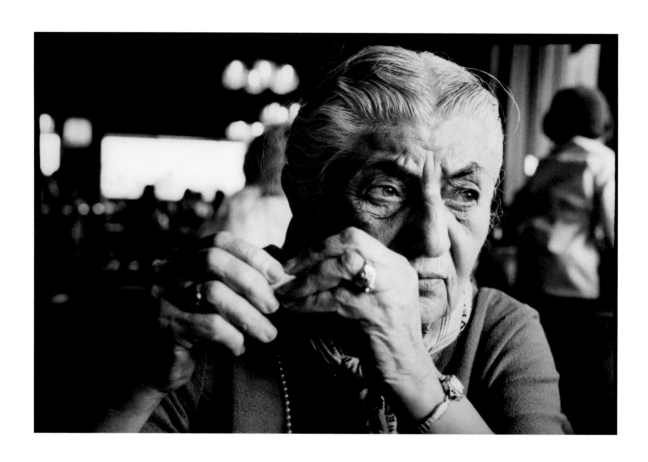

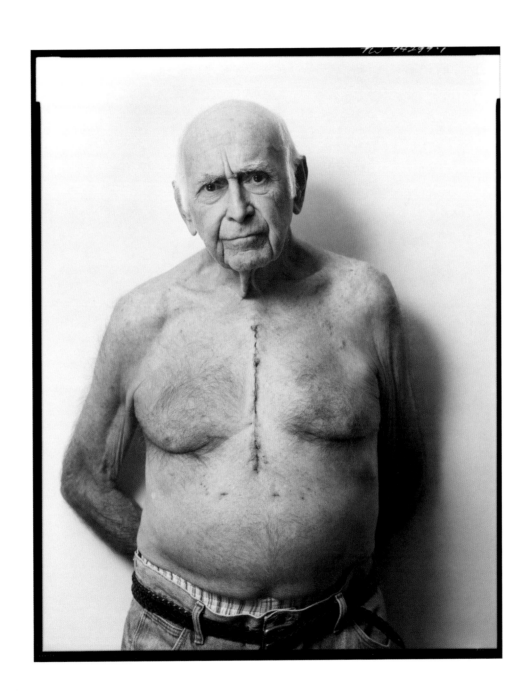

INDEX OF PHOTOGRAPHS

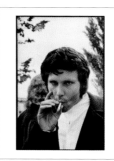
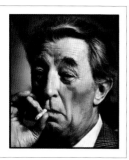

Jim Morrison
San Jose, CA
1968
JIM MARSHALL

Robert Mitchum
Santa Barbara, CA
1988
TIMOTHY WHITE

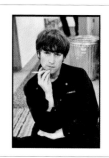
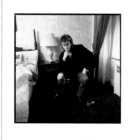

John Lennon
San Francisco, CA
1966
JIM MARSHALL

Julian Lennon
New York, NY
1986
TIMOTHY WHITE

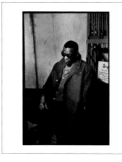
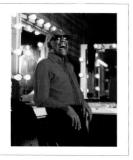

Ray Charles
San Francisco, CA
1960
JIM MARSHALL

Ray Charles
Culver City, CA
1991
TIMOTHY WHITE

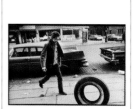
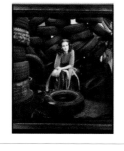

Bob Dylan
New York, NY
1963
JIM MARSHALL

Julia Roberts
New York, NY
1998
TIMOTHY WHITE

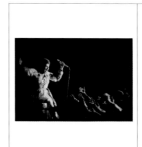
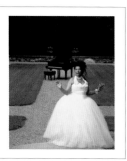

Aretha Franklin
San Francisco, CA
1970
JIM MARSHALL

Aretha Franklin
Detroit, MI
1996
TIMOTHY WHITE

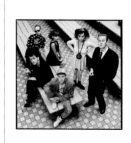
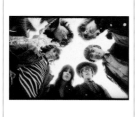

The Sugarcubes
New York, NY
1988
TIMOTHY WHITE

Jefferson Airplane
San Francisco, CA
1967
JIM MARSHALL

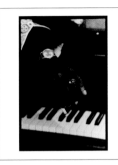 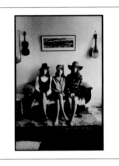

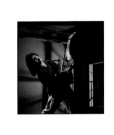 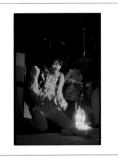

Thelonius Monk
New York, NY
1963
JIM MARSHALL

Bruce Springsteen
Malibu, CA
1991
TIMOTHY WHITE

Eddie Van Halen
Hollywood, CA
1988
TIMOTHY WHITE

Jimi Hendrix
Monterey, CA
1967
JIM MARSHALL

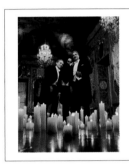

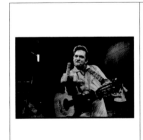

José Carreras,
Luciano Pavarotti,
and Placido Domingo
Vienna, Austria
1999
TIMOTHY WHITE

Joan Baez, Mimi Farina,
and Pauline Marden
San Francisco, CA
1968
JIM MARSHALL

Sly Stone
San Jose, CA
1972
JIM MARSHALL

Busta Rhymes
New York, NY
1997
TIMOTHY WHITE

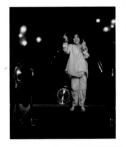 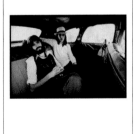

Johnny Cash
San Quentin, CA
1969
JIM MARSHALL

Elizabeth Taylor
Culver City, CA
2001
TIMOTHY WHITE

OutKast
Atlanta, GA
1994
TIMOTHY WHITE

Kenny Loggins
and Jim Messina
Los Angeles, CA
1972
JIM MARSHALL

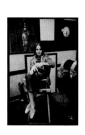
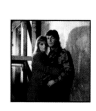
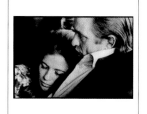

Michelle Phillips
Los Angeles, CA
1968
JIM MARSHALL

Michelle Phillips
Hialeah, FL
1988
TIMOTHY WHITE

Linda and Paul
McCartney
Chicago, IL
1989
TIMOTHY WHITE

June Carter
and Johnny Cash
Hendersonville, TN
1969
JIM MARSHALL

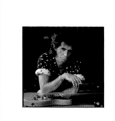
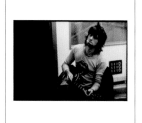
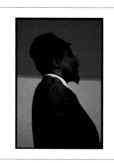

Keith Richards
New York, NY
1988
TIMOTHY WHITE

Keith Richards
Los Angeles, CA
1972
JIM MARSHALL

Thelonious Monk
Monterey, CA
1963
JIM MARSHALL

Jimmy Cliff
New York, NY
1987
TIMOTHY WHITE

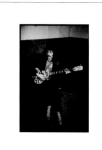
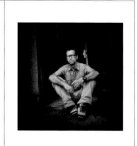

Allman Brothers Band
Macon, GA
1971
JIM MARSHALL

R.E.M.
Athens, GA
1989
TIMOTHY WHITE

Eric Clapton
Sausalito, CA
1967
JIM MARSHALL

Eric Clapton
Toronto, Canada
1997
TIMOTHY WHITE

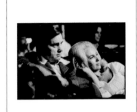

George Jones
and Tammy Wynette
Hendersonville, TN
1969

JIM MARSHALL

George Jones
and Randy Travis
Nashville, TN
1989

TIMOTHY WHITE

Jackson 5
Redwood City, CA
1980

JIM MARSHALL

Michael Jackson
New York, NY
1994

TIMOTHY WHITE

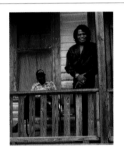
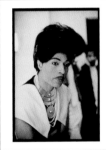

Little Richard
San Francisco, CA
1971

JIM MARSHALL

James Brown
Augusta, GA
1991

TIMOTHY WHITE

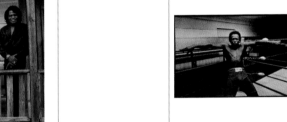

Miles Davis
San Francisco, CA
1971

JIM MARSHALL

Billy Joel
Boston, MA
1989

TIMOTHY WHITE

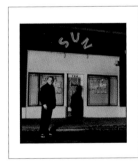

Jerry Lee Lewis
Memphis, TN
2004

JIM MARSHALL

Jerry Lee Lewis
Memphis, TN
2003

TIMOTHY WHITE

The Grateful Dead
San Francisco, CA
1967

JIM MARSHALL

Crowded House
New York, NY
1986

TIMOTHY WHITE

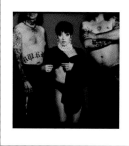

Woody Allen
Washington, DC
1963
JIM MARSHALL

Woody Allen
New York, NY
1994
TIMOTHY WHITE

Liza Minnelli
Los Angeles, CA
1977
JIM MARSHALL

Liza Minnelli
New York, NY
1996
TIMOTHY WHITE

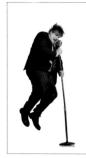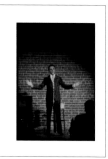
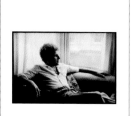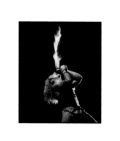

Chris Farley
West Hollywood, CA
1995
TIMOTHY WHITE

Lenny Bruce
San Francisco, CA
1959
JIM MARSHALL

Sammy Hagar
San Francisco, CA
1977
JIM MARSHALL

Sammy Hagar
West Hollywood, CA
1988
TIMOTHY WHITE

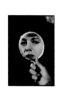
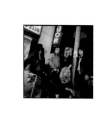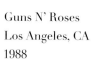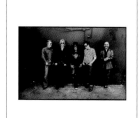

Shelley Winters
New York, NY
1963
JIM MARSHALL

Shirley MacLaine
Los Angeles, CA
1991
TIMOTHY WHITE

Guns N' Roses
Los Angeles, CA
1988
TIMOTHY WHITE

Velvet Revolver
Los Angeles, CA
2003
JIM MARSHALL

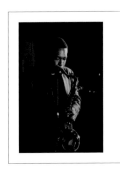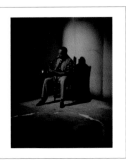

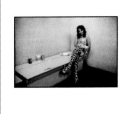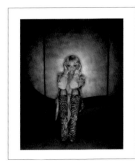

John Coltrane
New York, NY
1963

JIM MARSHALL

Grover Washington Jr.
Toronto, Canada
1999

TIMOTHY WHITE

Lil' Kim
New York, NY
2000

TIMOTHY WHITE

Alice Cooper
Denver, CO
1972

JIM MARSHALL

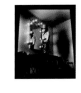

Ahmet Ertegun
Los Angeles, CA
1972

JIM MARSHALL

Ahmet Ertegun
New York, NY
1986

TIMOTHY WHITE

Circus clown
New York, NY
1962

JIM MARSHALL

Mishu
Culver City, CA
1992

TIMOTHY WHITE

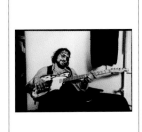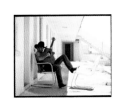

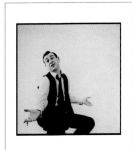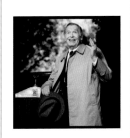

Waylon Jennings
San Francisco, CA
1975

JIM MARSHALL

Clint Black
Amboy, CA
1997

TIMOTHY WHITE

Shelley Berman
New York, NY
1962

JIM MARSHALL

Milton Berle
Beverly Hills, CA
1989

TIMOTHY WHITE

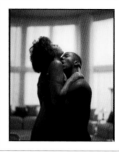

Whitney Houston
and Bobby Brown
Englewood, NJ
1993
TIMOTHY WHITE

Grace Slick
and Janis Joplin
San Francisco, CA
1967
JIM MARSHALL

Kris Kristofferson
Los Angeles, CA
1969
JIM MARSHALL

Chris Whitley
New Orleans, LA
1991
TIMOTHY WHITE

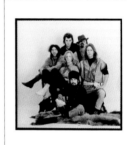

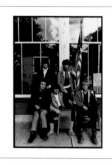

The Grateful Dead
San Francisco, CA
1967
JIM MARSHALL

Metallica
Shaker Heights, OH
1988
TIMOTHY WHITE

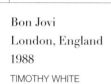

Moby Grape
Marin County, CA
1968
JIM MARSHALL

Bon Jovi
London, England
1988
TIMOTHY WHITE

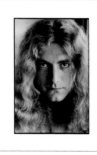

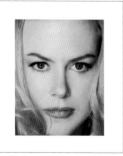

Robert Plant
Los Angeles, CA
1970
JIM MARSHALL

Nicole Kidman
New York, NY
2003
TIMOTHY WHITE

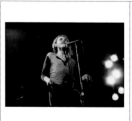

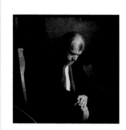

Joe Cocker
San Francisco, CA
Date unknown
JIM MARSHALL

Joe Cocker
New York, NY
1989
TIMOTHY WHITE

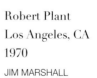

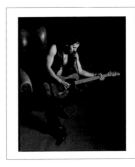
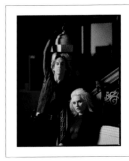
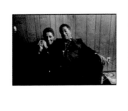

Bruce Springsteen
Beverly Hills, CA
1991
TIMOTHY WHITE

John Mayall
San Francisco, CA
1968
JIM MARSHALL

Iggy Pop
and Deborah Harry
Jersey City, NJ
1990
TIMOTHY WHITE

Carmen McRae
and Dizzy Gillespie
San Francisco, CA
1976
JIM MARSHALL

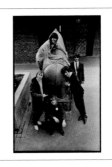
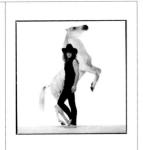

Buffalo Springfield
San Francisco, CA
1968
JIM MARSHALL

Jon Bon Jovi
London, England
1988
TIMOTHY WHITE

Sandra Bernhard
New York, NY
1988
TIMOTHY WHITE

Dr. John
San Francisco, CA
1983
JIM MARSHALL

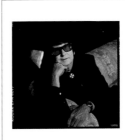
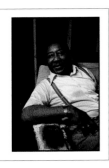

Roy Orbison
Los Angeles, CA
1987
TIMOTHY WHITE

Muddy Waters
Chicago, IL
1979
JIM MARSHALL

B. B. King
Toronto, Canada
1997
TIMOTHY WHITE

B. B. King
San Francisco, CA
Date unknown
JIM MARSHALL

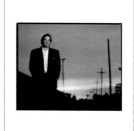

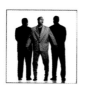
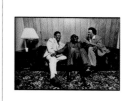

Oliver Stone
Los Angeles, CA
1991
TIMOTHY WHITE

Elia Kazan
New York, NY
1963
JIM MARSHALL

B. B. King, Albert King,
and Bobby Bland
Redwood City, CA
1981
JIM MARSHALL

Branford Marsalis
and band
New York, NY
1991
TIMOTHY WHITE

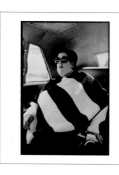
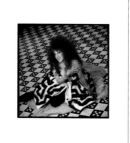

Frank Sinatra
and Dean Martin
San Francisco, CA
1964
JIM MARSHALL

George Clooney,
Brad Pitt, and Matt Damon
Burbank, CA
2006
TIMOTHY WHITE

Cass Elliot
Los Angeles, CA
1967
JIM MARSHALL

Bette Midler
New York, NY
1987
TIMOTHY WHITE

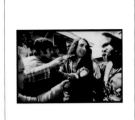 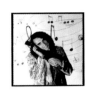 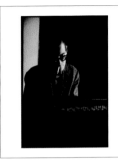

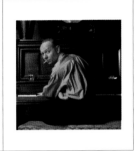

Tiny Tim
Los Angeles, CA
1967

JIM MARSHALL

Tiny Tim
New York, NY
1986

TIMOTHY WHITE

Bill Evans
New York, NY
1963

JIM MARSHALL

Joe Jackson
New York, NY
1989

TIMOTHY WHITE

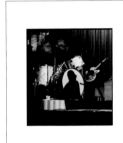 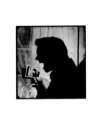

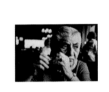 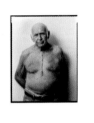

Ray Charles
New York, NY
1962

JIM MARSHALL

Jim Carrey
Los Angeles, CA
1998

TIMOTHY WHITE

Jim Marshall's mother
Tracy, CA
1976

JIM MARSHALL

Timothy White's father
Fort Lee, NJ
2005

TIMOTHY WHITE

ACKNOWLEDGMENTS

My appreciation and gratitude are given to the following people for their love, support, and friendship: Kirk Anspach, Amelia Davis, Chris McCaw, Ctein, John Varvatos, Steve Bing, John Botte, and Elicia Ho. And my brother, Timothy White.

— Jim Marshall

I would like to acknowledge the following people for sharing the passion and adventure of photography with me; I could not imagine it without you: Elicia Ho, Gus Philippas, Tim Carter, Elizabeth Benjamin, Kathrine Currey, Elizabeth Sullivan, Anthony DeCurtis, Bill Stockland, Maureen Martel, Dan Dibenedetto, John Botte, and Russell Ward. And, of course, Jim Marshall.

— Timothy White

MATCH PRINTS

Text and images copyright © 2010 by Jim Marshall and Timothy White
Introduction copyright © 2010 by Anthony DeCurtis

Additional photography credits: Page 21, left: courtesy Elicia Ho; right: courtesy Chuck Boyd. Page 26: Courtesy Gus Philippas.
Page 42: Photographer unknown. Page 51: © Jim Marshall and Timothy White.

All rights reserved. No part of this book may be used or reproduced in any manner
whatsoever without written permission except in the case of brief quotations embodied
in critical articles and reviews. For information, address Collins Design, 10 East 53rd Street, New York, NY 10022.

HarperCollins books may be purchased for educational, business, or sales promotional use.
For information, please write: Special Markets Department, HarperCollins*Publishers*, 10 East 53rd Street, New York, NY 10022.

First published in 2010 by
Collins Design
An Imprint of HarperCollins*Publishers*
10 East 53rd Street
New York, NY 10022
Tel: (212) 207-7000
Fax: (212) 207-7654
collinsdesign@harpercollins.com
www.harpercollins.com

Distributed throughout the world by
HarperCollins*Publishers*
10 East 53rd Street
New York, NY 10022
Fax: (212) 207-7654

Designed by Agnieszka Stachowicz

Library of Congress Control Number: 2008942437

ISBN 978-0-06-168912-3

Printed in China
First Printing, 2010